POSTCARD HISTORY SERIES

Youngstown

POSTCARDS FROM THE STEEL CITY

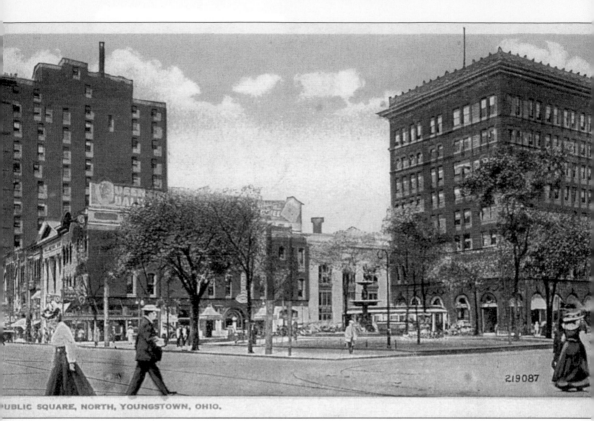

PUBLIC SQUARE, NORTH, YOUNGSTOWN, OHIO.

219087

PUBLIC SQUARE LOOKING NORTH. The first decade of the 20th century shows a growing city that was quickly shedding its 19th century small town persona. Two new skyscrapers, the Dollar Bank Building on the far right and the Wick Building on the left were completed in 1903 and 1909 respectively.

POSTCARD HISTORY SERIES

Youngstown

POSTCARDS FROM THE STEEL CITY

Donna M. DeBlasio

ARCADIA

Published by Arcadia Publishing,
an imprint of Tempus Publishing, Inc.
3047 N. Lincoln Ave., Suite 410
Chicago, IL 60657

Printed in Great Britain.

Library of Congress Catalog Card Number: 2003101430

For all general information contact Arcadia Publishing at:
Telephone 843-853-2070
Fax 843-853-0044
E-Mail sales@arcadiapublishing.com

For customer service and orders:
Toll-Free 1-888-313-2665

Visit us on the internet at http://www.arcadiapublishing.com

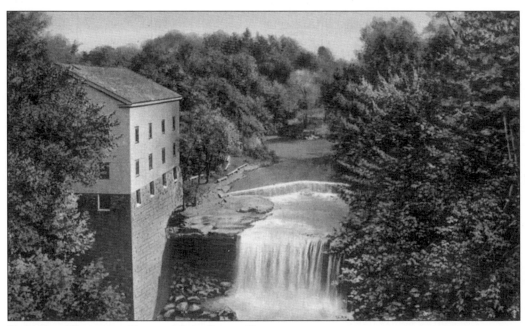

THE OLD MILL AND FALLS, MILL CREEK PARK.

CONTENTS

ACKNOWLEDGMENTS

The postcards that appear in *Youngstown, Ohio: Postcards From the Steel City* are a part of the collection owned by Sally Murphy Pallante, who generously allowed their use for this book. I thank her for parting with her collection for the duration of the writing of the manuscript.

The author consulted a number of sources in the writing of the book. For general local history, I relied especially on the following primary and secondary sources:

PRIMARY:

Youngstown Vindicator, 1900–1940.

Youngstown City Directories, 1900–1940.

SECONDARY:

Aley, Howard C. *A Heritage to Share: The Bicentennial History of Youngstown and Mahoning County, Ohio*. Youngstown: Bicentennial Commission of Youngstown and Mahoning County, 1975.

Blue, Frederick J., William D. Jenkins, H. William Lawson and Joan Reedy, *Mahoning Memories: A History of Youngstown and Mahoning County*. Virginia Beach, VA: Donning Publishing, 1995.

Butler, Joseph G., Jr. *Youngstown and the Mahoning Valley*. 3 vols. Chicago and New York: American Historical Society, 1921.

Cart, Sarah, Paul Jagnow and Robert McFerren. *These Hundred Years: A Chronicle of the 20th Century as recorded in the pages of the Youngstown Vindicator*. Youngstown: The Vindicator Printing Co., 2000.

Jenkins, William D. *Steel Valley Klan: The Ku Klux Klan in Ohio's Mahoning Valley*. Kent, OH: Kent State University Press, 1990.

Linkon, Sherry Lee and John Russo, *Steel Town, USA: Work and Memory in Youngstown*, Lawrence, KS: University Press of Kansas, 2002.

Palmer, William J. "To Raise the Standard of Architecture: The Work and Vision of Charles Henry and Charles Frederick Owsley." MA Thesis, Youngstown State University, 2000.

For Mill Creek Park, the following two sources were invaluable and I drew heavily on both:

Melnick, John C. *The Green Cathedral: History of Mill Creek Park.* Youngstown: Youngstown Lithographing Co., 1976.

Williams, Bridget M. *The Legacy of Mill Creek Park: A Biography of Volney Rogers.* Youngstown: Youngstown Lithographing Co., 1992.

For Idora Park, I relied on my own research and the recent book by Rick Shale and Charles J. Jacques, Jr.:

DeBlasio, Donna M. "The Immigrant and the Trolley Park in Early 20th Century Youngstown." *Rethinking History.* Spring, 2001. 75-91.

Shale, Rick and Charles J. Jacques. *Idora Park: The Last Ride of Summer.* Jefferson, OH: Amusement Park Books, 1999.

I would also like to acknowledge the work of my graduate student, Heather Lynn Olsen, who painstakingly scanned all the postcards into the computer and also edited the text. Thanks also to Dr. Peter Kasvinsky, Dean of the School of Graduate Studies and Research at Youngstown State University, who provided a summer research assistant grant that allowed me to hire Heather. Gratitude goes to my colleagues Dr. Tom Leary and Dr. Diane Barnes, who read parts of the manuscript and made helpful suggestions, as well as the Chair of the History Department, Dr. Martha Pallante, for her support. The research Carol Salmon and Marcelle Wilson did on Civil War monuments was helpful in describing Youngstown's "Man on the Monument." Carol also researched the history of the steel industry in Youngstown, which was of assistance in the creation of this book. I extend my appreciation to both of them for their diligent work. Finally, I would like to thank my husband, Brian R. Corbin, for his continued love, support, and encouragement.

 The royalties from the sale of this book will go to the Center for Historic Preservation at Youngstown State University and the Irish-American Archival Society.

INTRODUCTION

At the dawn of the 20th century, a vibrant city grew rapidly along the banks of the Mahoning River in northeastern Ohio. Established in 1796 by John Young, the city that bears his name started life as a tiny village on the edge of what was then the "wild west." From these humble origins, Youngstown became one of the largest steel manufacturers in the world by 1920. The iron and steel industry emerged early in the Mahoning Valley's history. In 1803, brothers James and Daniel Heaton built the first blast furnace west of the Alleghenies in the nearby community of Struthers. The iron industry really did not begin to flourish, however, until the 1850s, with the discovery of extensive local deposits of coal and iron ore. Coupled with the developing railroad industry, the demand for the products of the Mahoning Valley's blast furnaces and rolling mills dramatically increased.

Steel, which is an alloy of iron and carbon, was unable to be mass-produced until the invention of the Bessemer Converter in the late 1850s. Named for its creator, Englishman Sir Henry Bessemer, this new technology revolutionized the ferrous industries. In 1875, Andrew Carnegie opened his first steel mill in Pittsburgh, Pennsylvania, which he named the Edgar Thompson Works (or "E.T.") after his former boss at the Pennsylvania Railroad. The Ohio Steel Company (which eventually became a part of the U. S. Steel Corporation) poured the Mahoning Valley's first Bessemer Process steel in 1895. Other steel makers quickly followed the Ohio Steel Company's lead, thus giving Youngstown and the Mahoning Valley its signature industry and image. The Mahoning Valley's mature industry just prior to World War II was represented by three major steel manufacturers: the locally-owned Youngstown Sheet and Tube Company, the Republic Steel Corporation, and Carnegie Steel (a division of the United States Steel Corporation). Along with these giants, there were companies in numerous support industries, including the William B. Pollock Company, which manufactured blast furnaces and other steel industry machinery; United Engineering and Foundry; and Commercial Shearing Corporation. Thousands of families relied on steel and related ferrous industries for their livelihood.

With the expansion of the steel industry came a great need for thousands of unskilled workers. The immigrants flooding into the United States from eastern and southern Europe came to cities like Youngstown to fill the positions in the steel mills hungry for their labor; at one time more than 30,000 persons worked in steel or a related industry. The newcomers contributed to Youngstown's rapid population increase from 45,000 in 1900 to 80,000 in 1910, 120,000 in 1920, and 170,000 by 1930. With such a large immigrant (and working class) population, the "Steel City" often found itself beset by conflict. The often uneasy relations between the classes and ethnic groups manifested itself in major steel strikes in 1916, 1919, 1937, 1949, 1952, and 1957. While local community leaders attempted to ameliorate class tensions and cultural differences by promoting such programs as Americanization classes, the fact remained that the Mahoning Valley was a scene of class and ethnic struggle for years to come.[1]

As the city grew, its desire to promote an image of itself as an important and booming community was expressed in its built environment. During the first three decades of the 20th century, Youngstown's downtown skyline changed dramatically. In 1900, there were still remnants of a community that was more small town than city. Most of the buildings were no more than four or five stories tall and of load-bearing masonry or wood construction. As early as 1909, when the Mahoning National Bank announced that it was building a new headquarters on the southwest corner of Central Square and Market Street, the *Youngstown Vindicator* proclaimed that "Should the Mahoning bank [sic] decide on the building of a new skyscraper, and the project of a new modern hotel on the Tod House site be carried out, Central Square would assume in its architecture a truly metropolitan appearance."[2] By 1930, the commercial district housed a number of steel-framed skyscrapers, important public buildings, and large department stores. With the exception of the Art Deco Central (now Metropolitan) Tower, the mature city's new buildings hid modern construction techniques behind traditional facades. Youngstown's new structures were the work of not only important local architects such as Charles F. and Charles H. Owsely and Louis and Paul Boucherle, but also those with a national reputation such as Albert Kahn and Daniel Burnham.

The quest to become a modern metropolis also manifested itself in the improvement in the quality of life. Youngstown industrialist Joseph G. Butler founded the nation's first museum dedicated solely to American Art, which bears his name. Stambaugh Auditorium, the modern Neo-Classical concert facility, still graces the north side of the city. The foresight of Volney Rogers led to the establishment of one of the nation's finest urban parks, Mill Creek Park, in 1891. The human-made lakes, drives, pavilions, and other amenities enhanced the wild beauty of the park's forestland and topography. Park goers spent many leisure hours there, whether boating, swimming, picnicking or hiking. There was even a sulphur spring, which many believed had restorative powers. While Mill Creek Park provided an oasis in a natural setting, its neighbor, Idora Park, furnished the mechanical thrills and excitement of amusement park rides and novelties. Starting as a small trolley park, the "pleasure resort" grew into an important local institution, with a world-class roller coaster and other hair-raising attractions, as well as one of the largest dance floors in the region. Yet even these seemingly benign places designed for recreation and rejuvenation proved to be contested ground in defining and utilizing civic spaces. Each segment of the community had their own vision of what the Mahoning Valley was and should become; these divergent views often played themselves out in the public arena.

The vintage postcards provide a graphic representation of Youngstown's seemingly overnight transformation from provincial village to industrial metropolis. These images serve as a reminder of the vibrancy and excitement that typified many maturing communities as they entered the new century. What they do not show are the issues and problems that were magnified by a growing population such as pressures for more housing and expanded community services and infrastructure. There were also questions raised by the newcomers to the area and a growing working class—how would community movers and shakers respond to and integrate the changing composition of the populace? How would the working class and immigrants infuse their own culture and needs into the dominant population? The postcard views of the built environment show only the surface; those who examine them now have to look beyond the superficial to understand the whole story of Youngstown in the early 20th century.

[1] Class, racial and ethnic conflict is thoughtfully examined in Sherry Lee Linkon and John Russo, *Steel Town, USA: Work and Memory in Youngstown*, (Topeka: University Press of Kansas, 2002).

[2] "Mahoning National Bank Buys Andrews & Hitchcock Block," *Youngstown Vindicator*, 6 October 1909.

One
DOWNTOWN

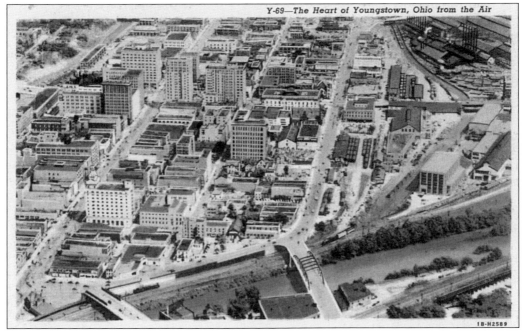

Y-69—The Heart of Youngstown, Ohio from the Air

THE HEART OF YOUNGSTOWN, OHIO FROM THE AIR. This aerial shot of downtown Youngstown is taken from the southwest, probably about 1940. In the upper right hand corner is a section of the Republic Steel plant. The Mahoning River can be seen in the foreground.

CENTER OF DOWNTOWN YOUNGSTOWN, LOOKING NORTH. The core of downtown Youngstown can be seen in this postcard. In the center foreground are the buildings that comprised the United Engineering and Foundry Company. Originally, the William B. Pollock Company, a major manufacturer of blast furnaces, ladle cars and other large iron and steel industry equipment, occupied the United property. The Pollock Company later moved its operations to the far east side of downtown Youngstown. The tall buildings seen here are, from left to right, the Hotel Pick-Ohio, the Strouss-Hirshberg Department Store, Union National Bank, the Stambaugh Building, Central Tower and the Mahoning National Bank Building.

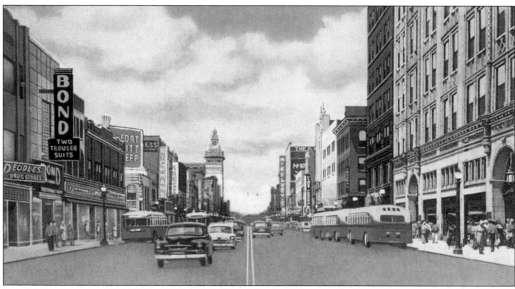

LOOKING WEST ON FEDERAL STREET. By the 1940s, downtown Youngstown fairly bustled with activity. This view, looking west on West Federal Street, shows many of the commercial establishments that existed at the time. On the far right is a detail of the Strouss-Hirshberg Department Store, a Youngstown institution since the mid-19th century. Next to the Strouss building is one of the earliest skyscrapers in Youngstown, the Wick Building, which was designed by noted Chicago architect Daniel Burnham.

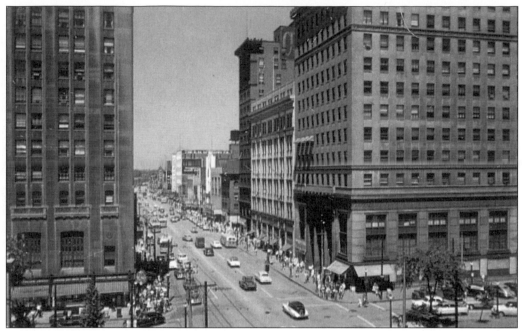

LOOKING WEST ON FEDERAL STREET FROM PUBLIC SQUARE. This shot of West Federal Street was taken fairly close to Central Square. In the left foreground is a section of the last skyscraper built in Youngstown, the Art Deco Central Tower. On the right is the Union National Bank building. The Strouss building is sandwiched between it and the Wick Building.

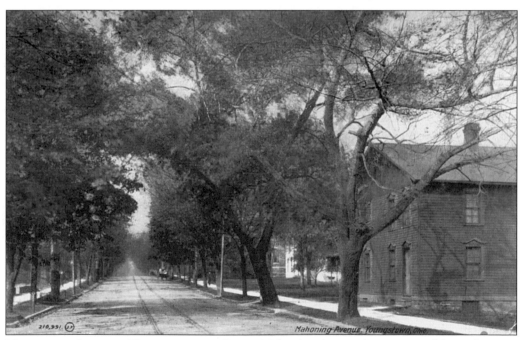

MAHONING AVENUE, YOUNGSTOWN, OHIO. Mahoning Avenue is now one of the major east–west thoroughfares in the city of Youngstown. In the early 20th century, it was still largely residential, with a number of single family residences fronting a tree-lined street.

13

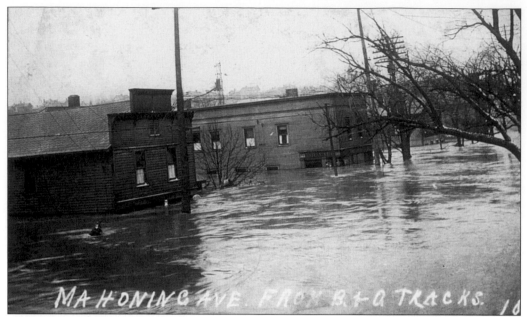

MAHONING AVE. FROM B.+O. TRACKS. 10

MAHONING AVENUE FROM B & O TRACKS. Mahoning Avenue starts at the Spring Common bridge adjoining downtown Youngstown, near the Mahoning River. In 1913, the Mahoning Valley experienced a devastating flood, when the Mahoning River overflowed its banks. Property up and down the river was damaged or destroyed. This view shows the height of the flood waters, reaching to the second stories of the buildings and the tops of trees.

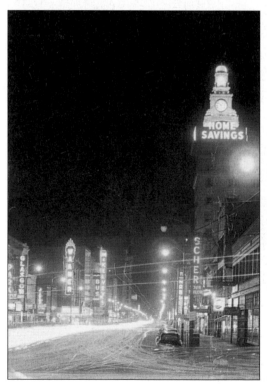

LOOKING EAST FROM SPRING COMMON. Taken *c.* 1940, this night scene looks east along West Federal Street from the Spring Common Bridge. On the right is the glowing tower of the Home Savings and Loan building. Directly opposite, the marquee for the Warner Theater (now Powers Auditorium) is clearly visible.

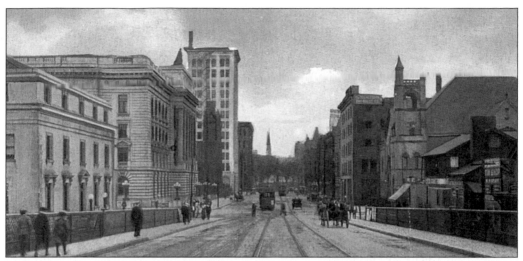

MARKET STREET LOOKING NORTH. People entering downtown from the south side of the city were greeted by this vista as they came down the Market Street Bridge. The growing city had several new buildings prior to the start of the First World War, including the county courthouse (second building on the left) and the new home of the Mahoning National Bank, to the immediate right of the courthouse. The church directly across from the courthouse is the Westminster Presbyterian Church, which later moved out of downtown to its current location in Boardman Township, south of the city.

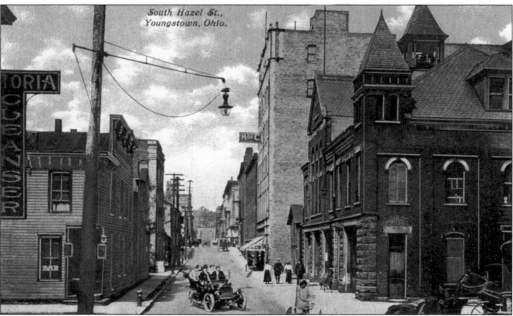

SOUTH HAZEL STREET. Located in downtown Youngstown, this view of Hazel Street is taken *c.* 1910 from the intersection with W. Boardman Street and is looking north toward the center of town. On the far right is the fire station; the tall building next to it is the 1908 Knights of Columbus hall. The presence of such an imposing edifice for the Knights of Columbus at a relatively early date speaks to the growing numbers and influence of Catholics in what was then a predominately Protestant community. The small Italianate building directly across from the fire station was a saloon.

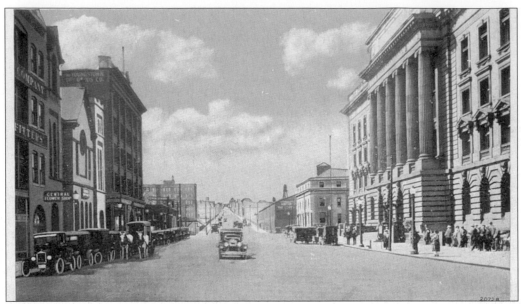

MARKET STREET LOOKING SOUTH. This *c.* 1915 view of the northern part of Market Street shows a detail of the recently completed Mahoning County Courthouse on the left. Just beyond the courthouse is the Federal Post Office building. Across the street are the H. S. Williams Company (a furniture store), Central Christian Church, the Youngstown Dry Goods Company and the Westminster Presbyterian Church. None of these buildings on the east side (left) are extant.

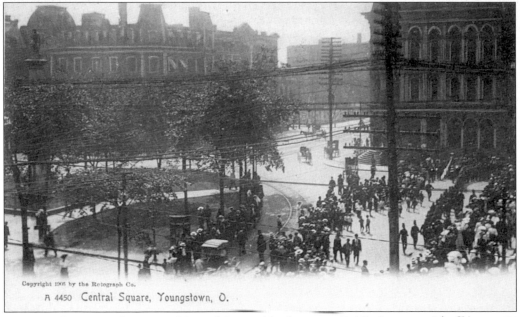

CENTRAL SQUARE. This view of Central Square (also known as Public Square or "the Diamond") in 1905 depicts two 19th century Youngstown landmarks that no longer exist. On the right is the Grand Opera House, which opened its doors in 1872. This lovely French Second Empire building was built by P. Ross Berry, the area's leading African-American brick mason. On the left is the Tod House Hotel, one of the first important downtown hostelries, also built by Berry.

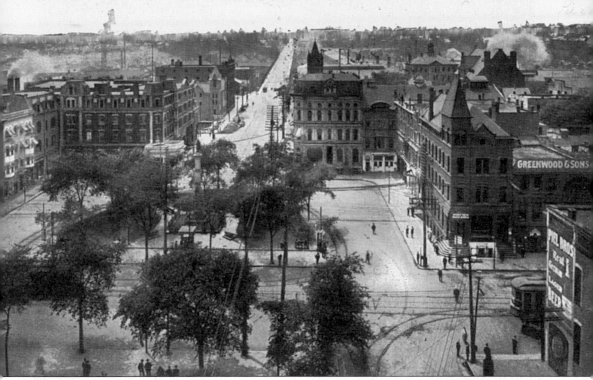

PUBLIC SQUARE, YOUNGSTOWN, LOOKING SOUTH. The core of downtown Youngstown was a lively city *c.* 1905. The view depicts the newly completed Market Street viaduct in the distant background. To meet the city's image of itself as a progressive urban center, the majority of the buildings seen here would be torn down within the next 20 years and replaced by impressive skyscrapers.

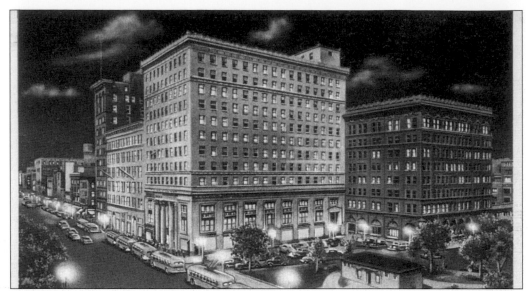

NIGHT VIEW OF CENTRAL SQUARE LOOKING NORTHWEST. The buildings occupying the northwest side of Central Square all still exist, although the Square itself was remodeled in the late 1960s. The Dollar Savings and Trust Building (now National City Bank) is on the far right; however, the red brick and terra cotta exterior was modernized in the late 1970s and re-clad in granite.

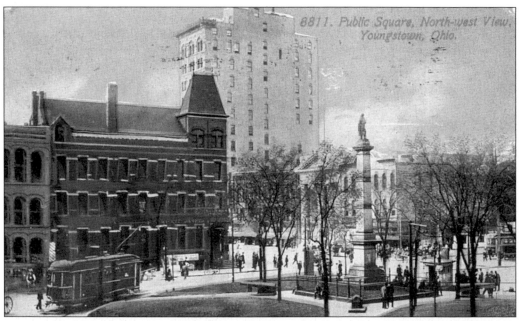

PUBLIC SQUARE, YOUNGSTOWN, LOOKING NORTHWEST. This view looking northwest at the Square predates the previous image by nearly 40 years. While the Civil War memorial seen in the center of the image still stands, all of the other buildings, except the Wick Building in the center background, are gone. The red masonry structure in the left foreground once housed the Commerce National Bank and by 1913, the Central Savings and Loan. The latter institution replaced this building with the Central Tower in 1929.

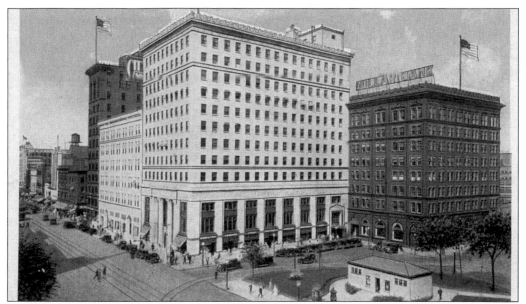

NORTHWEST CORNER OF PUBLIC SQUARE. This view of Public Square dates from the late 1920s. By this time, three of downtown's most important commercial buildings—from right to left, the Dollar Bank, Union National Bank, and the Wick Building—are all visible.

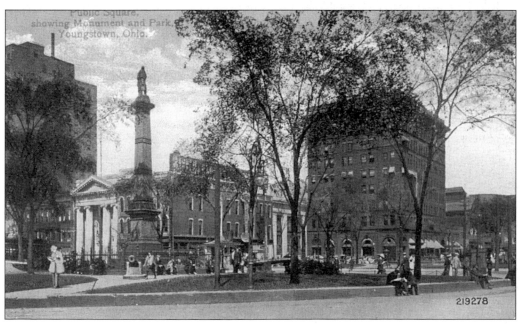

PUBLIC SQUARE SHOWING MONUMENT AND PARK. An earlier image than the preceding depicts the "Man on the Monument," Youngstown's Civil War memorial. The Union National Bank is housed in the Neo-Classical Revival building to the left of the monument; in a few years, it will be replaced by a far more imposing skyscraper.

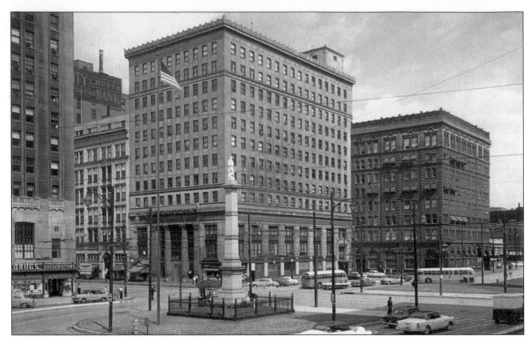

CENTRAL SQUARE. This *c.* 1960 image of Central Square shows a mature, modern downtown. Just on the edge of the photograph is the city's last skyscraper—the 18 story Central (now Metropolitan) Tower.

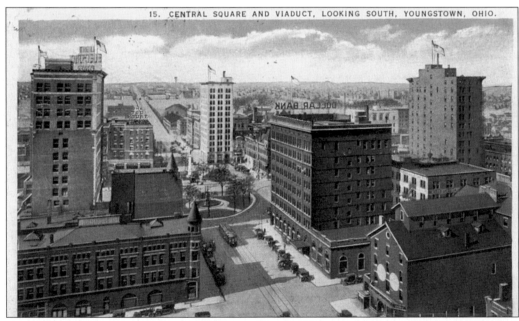

CENTRAL SQUARE AND VIADUCT LOOKING SOUTH. Taken *c.* 1925, most of the downtown's modern buildings are evident in this postcard. Some of the older structures that would be torn down in the next few years include the structure in the lower right foreground. This building housed the J. H. Fitch Co., which the city directory described as "wholesale grocers and confectioners, mfrs. of crushed fruits, jellies and preserves."

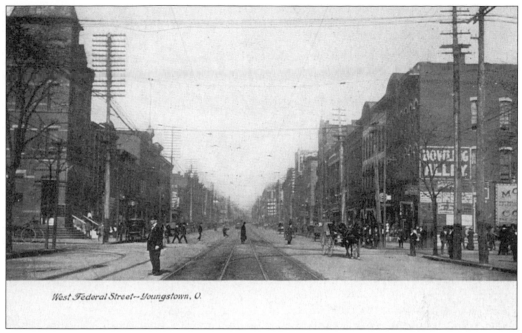

West Federal Street--Youngstown, O.

WEST FEDERAL STREET. This is an early 20th century view of Federal St. looking west from Central Square. Note the trolley tracks running through the middle of the street. Youngstown had horse cars beginning in 1874; the first electric streetcars appeared in about 1891.

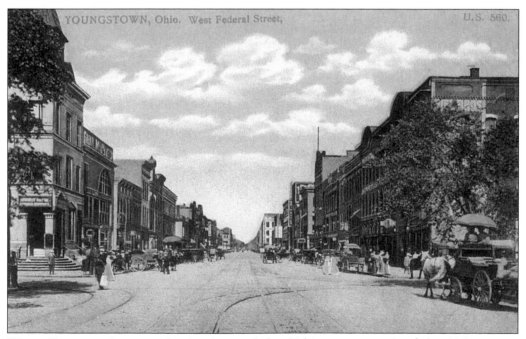

YOUNGSTOWN, Ohio. West Federal Street, U.S. 560.

WEST FEDERAL STREET. At the dawn of the 20th century, much of the 19th century downtown remained intact. Many of the buildings here would be replaced by newer structures, reflecting the growing city's desire for larger, more impressive edifices.

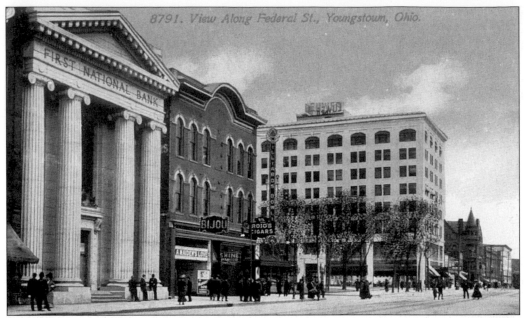

VIEW ALONG FEDERAL STREET. Taken in about 1910, this is a view of the northwest corner of West Federal Street and Central Square. Within fifteen years, the First National Bank built itself a much larger, grander edifice. The building to the right of the bank housed an early nickelodeon, the Bijou Theatre.

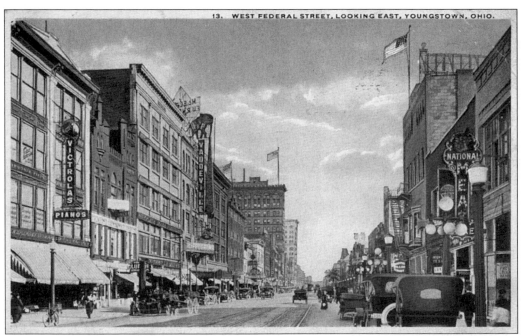

13. WEST FEDERAL STREET, LOOKING EAST, YOUNGSTOWN, OHIO.

WEST FEDERAL STREET LOOKING EAST. The foreground shows the 200 block of West Federal Street at about the time of the First World War. The large "Vaudeville" sign is on the Hippodrome Theatre; to its immediate right is the G.M. McKelvey Company, one of the city's largest department stores.

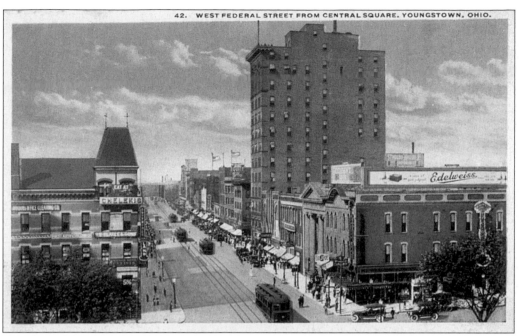

WEST FEDERAL STREET FROM CENTRAL SQUARE. This is another view of the far eastern end of West Federal Street and the Central Square at about the time of the First World War.

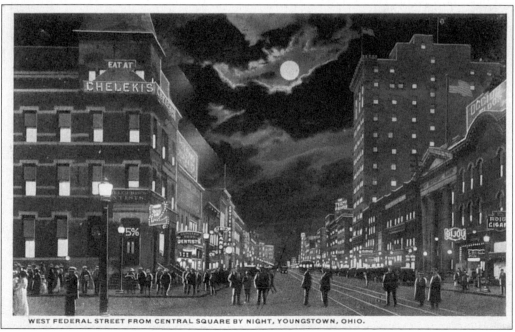

WEST FEDERAL STREET FROM CENTRAL SQUARE BY NIGHT, YOUNGSTOWN, OHIO.

WEST FEDERAL STREET FROM CENTRAL SQUARE BY NIGHT. Even at night, downtown Youngstown was a busy place. The Central Savings and Loan building on the left also housed Chelekis, a popular lunch spot, which opened in 1910.

23

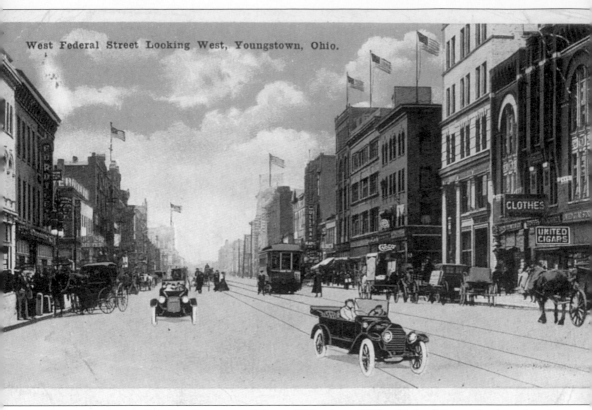

West Federal Street Looking West, Youngstown, Ohio.

WEST FEDERAL STREET LOOKING WEST. This vista of West Federal Street begins with the blocks closest to Central Square. The third building on the right side is the Federal Building, which is notable for several reasons: it is Youngstown's first skyscraper, it was designed by the nationally renowned architect Daniel Burnham, and it housed the first offices of the Youngstown Sheet and Tube Company. Built between 1898-1899, the four-story structure exhibits elements of both the Neo-Classical Revival and Commercial styles.

Two
PUBLIC AND COMMERCIAL BUILDINGS

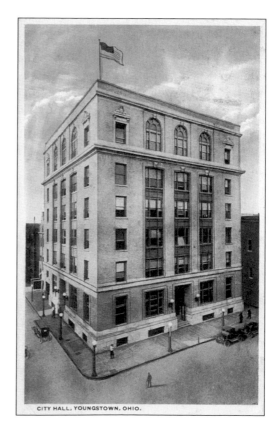

CITY HALL. With the rapid growth of Youngstown in the early 20th century, the city's government quickly outgrew its first city hall, located at 116 W. Boardman Street. The city hired Charles F. Owsley to design its new city hall in 1912. Opening in 1914, the Neo-Classical Revival building is six stories tall with a yellow brick façade. In the mid-1960s, the exterior was altered, but still retains much of its integrity, as does the interior. The City Council Chambers was restored to its original Neo-Classical beauty in 2002.

CITY HALL, YOUNGSTOWN, OHIO.

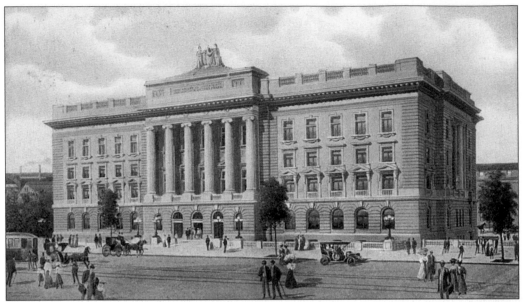

Mahoning County Courthouse. Youngstown became the county seat of Mahoning County in 1876. The 1908-1910 building seen here replaced the earlier Second French Empire structure located at the north end of downtown. The firm of Owsley and Boucherle designed the $2,000,000 new building in the popular Second Renaissance Revival style. The Indiana limestone clad building houses six courtrooms and public and private offices.

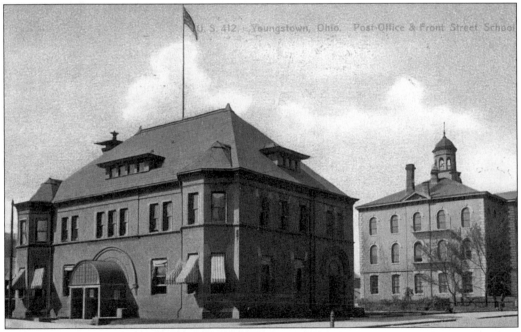

Main Post Office and Front Street School. Front Street lies along the north side of the Mahoning River in downtown Youngstown. As industry developed along the river and the commercial sector grew, public buildings like the federal post office on the left and the Front Street School served the needs of the growing community.

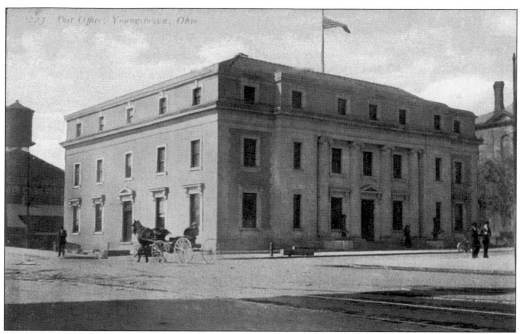

POST OFFICE. In 1908, the post office went through a major renovation. For two years, the federal government moved the post office's operations to the new Knights of Columbus building on Front Street.

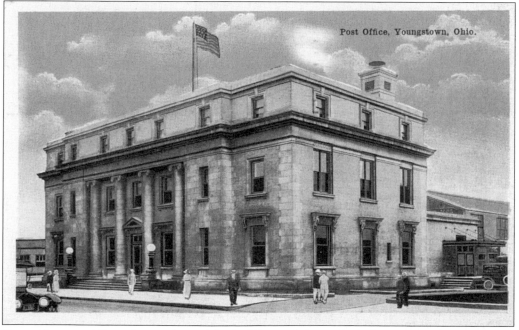

POST OFFICE. Like other major public buildings of the early 20th century, the post office featured classical elements. Many Americans believed that the styles of ancient Greece and Rome reflected the idea that America was the culmination of the democracy of Greece and the republicanism of Rome.

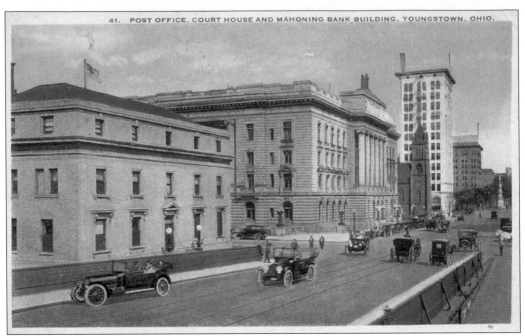

POST OFFICE, COURTHOUSE, AND MAHONING NATIONAL BANK. This vista looks north into downtown Youngstown. The Mahoning Bank still has its original five bay Market Street façade. The church next to the Mahoning Bank building is First Baptist Church.

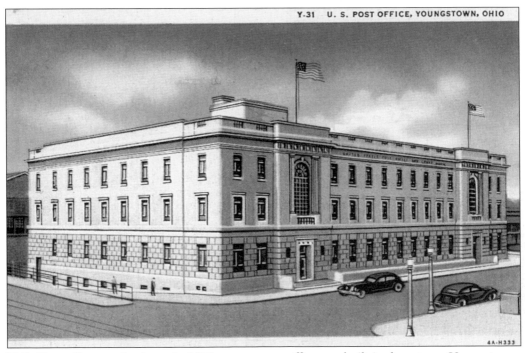

U.S. POST OFFICE. In the early 1930s, a new post office was built in downtown Youngstown. This is a much larger structure than the one seen in the preceding three images. It is a Second Renaissance Revival building that now serves as the City Hall Annex.

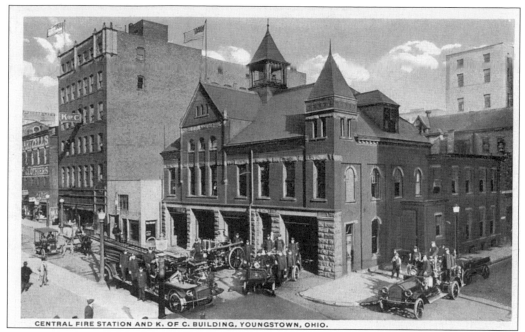

CENTRAL FIRE STATION AND K. OF C. BUILDING, YOUNGSTOWN, OHIO.

CENTRAL FIRE STATION. Located in downtown Youngstown, this Romanesque Revival building served as the main fire station for the city. In 1911, the Youngstown fire department was one of the first in the nation to use motorized vehicles.

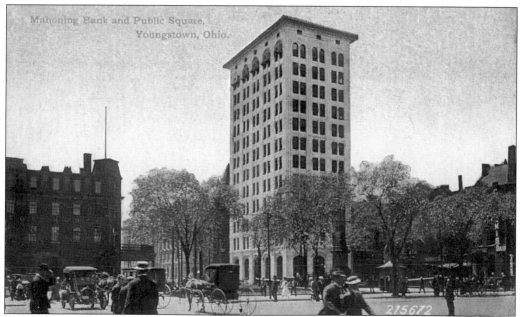

Mahoning Bank and Public Square, Youngstown, Ohio.

215672

MAHONING NATIONAL BANK AND PUBLIC SQUARE. Detroit's Albert Kahn, who is perhaps better known for designing factories, served as architect of this new building for the Mahoning National Bank. This financial institution was organized in 1868.

29

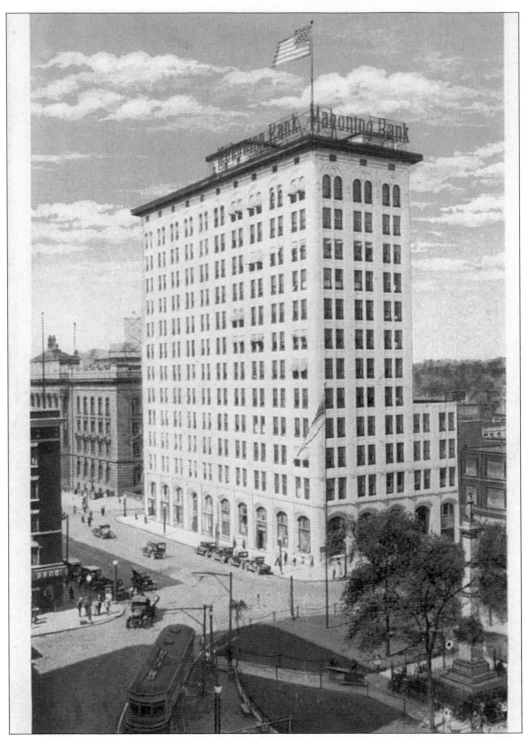

MAHONING NATIONAL BANK. In the 1920s, Albert Kahn added an additional five bays on the south side of his original 1909 building for the growing Mahoning National Bank, now known as Sky Bank.

FIRST NATIONAL BANK. Located on the far eastern end of West Federal Street, this banking firm originated in 1850 as the Mahoning County Bank and became First Union Bank in 1863. The bank replaced this 1909 structure in 1925 with a much larger 13 story Neo-Classical Revival edifice that is still standing. In 1931, First National merged with the Commercial Bank to become Union National Bank. It is now known as Bank One.

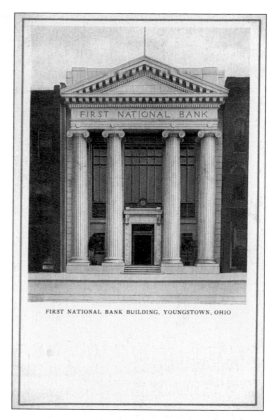

FIRST NATIONAL BANK BUILDING, YOUNGSTOWN, OHIO

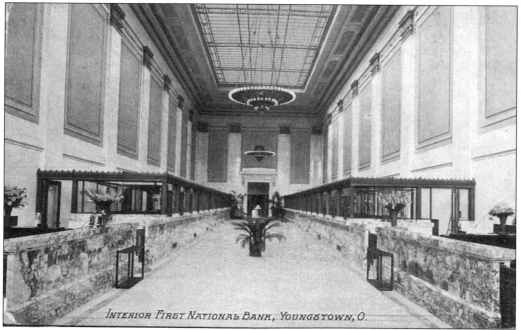

INTERIOR FIRST NATIONAL BANK, YOUNGSTOWN, O.

INTERIOR, FIRST NATIONAL BANK. The Neo-Classical interior reflects the desire to impress customers with the fiscal strength and sobriety of a leading financial institution.

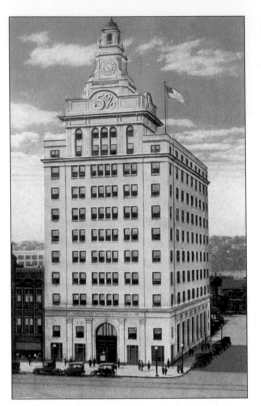

HOME SAVINGS BANK BUILDING. One of Youngstown's foremost architects, Charles F. Owsley, designed this 1919 Colonial Revival building. Its outstanding clock tower is brightly lit at night, a familiar sight on the Youngstown skyline.

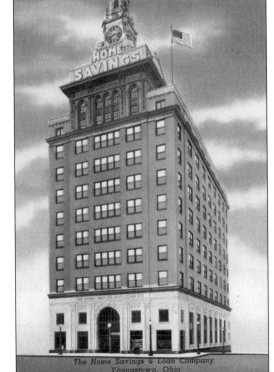

HOME SAVINGS AND LOAN COMPANY. The Home Savings and Loan began in 1889 as the Home Building and Loan Company. The bank was originally located on Central Square before moving into its new home further west on West Federal Street.

CENTRAL TOWER. One of the region's finest Art Deco buildings, this 18 story skyscraper was designed by Youngstown architect Morris W. Scheibel for the Central Savings and Loan in 1929. From the Egyptian-inspired entrance to the chevron-patterned tiles at the top, this beautiful building is basically unaltered. It boasts a gorgeous, lavish Art Deco lobby that also retains its integrity. The Metropolitan Savings and Loan (now Metropolitan Savings Bank) purchased the building in 1976 and renamed it Metropolitan Tower.

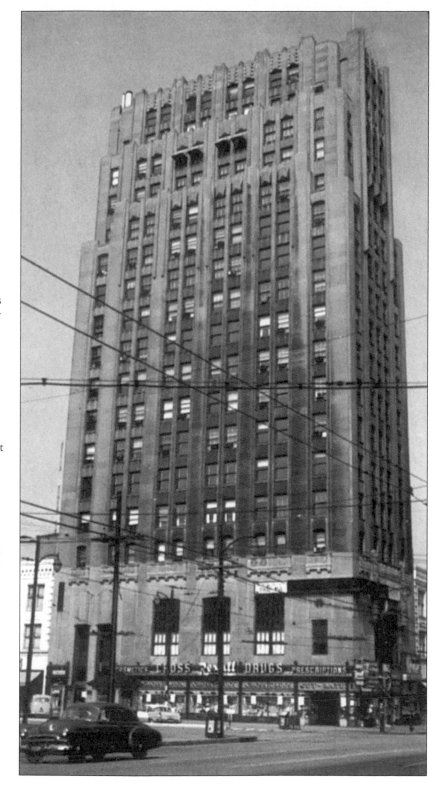

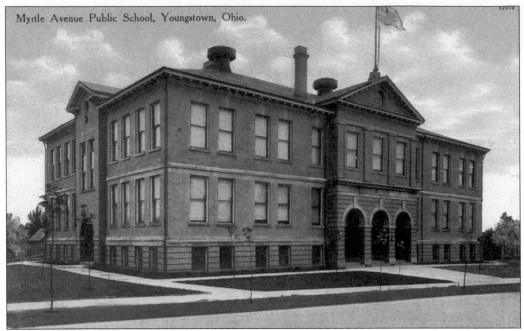

Myrtle Avenue Public School, Youngstown, Ohio.

MYRTLE AVENUE SCHOOL. In the first decade of the 20th century, Youngstown's south side grew quickly, thanks to the completion of the Market Street viaduct and the trolley system. To meet the needs of an expanding population, the city constructed more schools such as this one, which was built *c.* 1905 on the corner of Myrtle and Hillman Avenues.

RAYEN SCHOOL. Built between 1862 and 1866, the Rayen School was Youngstown's first public high school. It was named for Judge William Rayen. Simeon Porter designed this Greek Revival structure, which expresses some elements of the Italianate style. African-American brick mason P. Ross Berry laid the brickwork. The building was enlarged twice: in 1894 and in 1910. This structure now houses the offices of the Youngstown Board of Education.

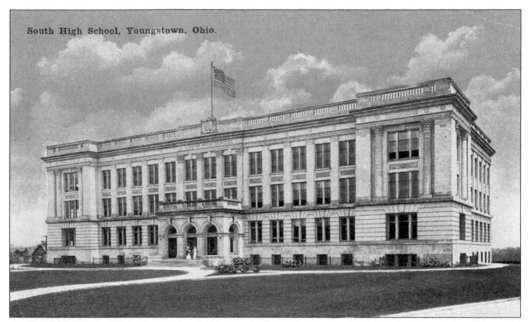

South High School, Youngstown, Ohio.

SOUTH HIGH SCHOOL. In keeping with the early 20th century taste for classicism in architecture, Charles F. Owsley designed the first high school on the south side in the Second Renaissance Revival style. Owsley, who was in partnership with his father, Charles H. Owsely, was a graduate of the Penn State School of Architecture as well as a student at an atelier of Paris' Ecole des beaux arts. The two Owsleys, along with their partners Louis and Paul Boucherle, designed some of the most important buildings in Youngstown in the late 19th and early 20th centuries.

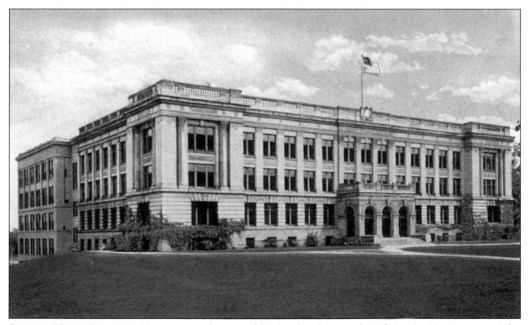

SOUTH HIGH SCHOOL. Youngstown's second high school opened its doors in 1911, to meet the needs of the rapidly growing south side as well as the increasing numbers of young people attending high school.

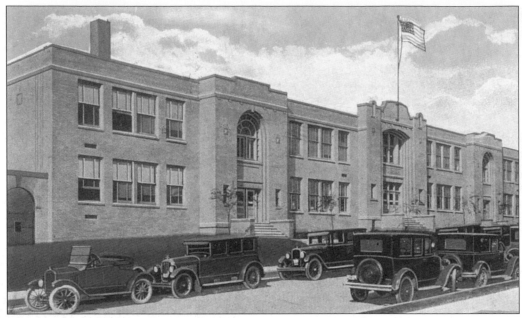

WEST HIGH SCHOOL. The postcard misidentifies this as a high school; it was actually an elementary school located on the corner of Mahoning and West Avenues, near downtown.

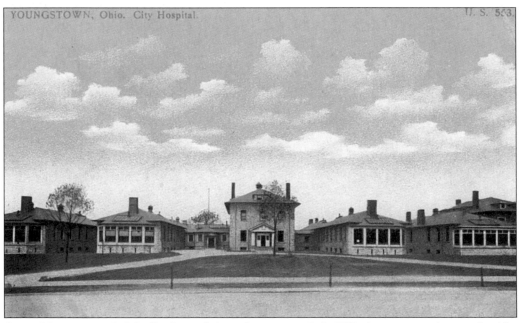

YOUNGSTOWN, Ohio. City Hospital. U. S. 553.

CITY HOSPITAL. Originally located in a house on Oak Hill Avenue on the south side, Youngstown City Hospital opened its doors in 1883. In 1902, the facility became the city's first modern hospital when it opened the buildings seen here.

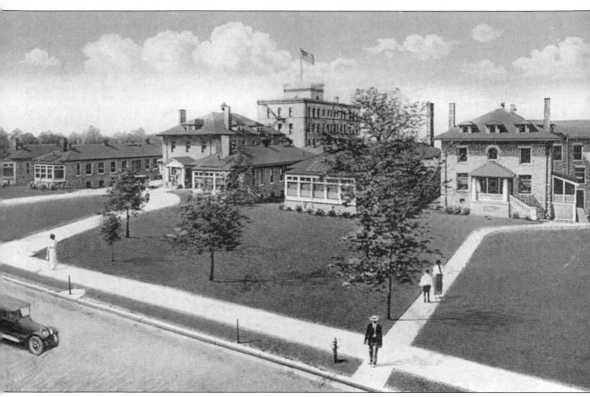

CITY HOSPITAL. Many of Youngstown's leading citizens were involved in raising money for the new City Hospital buildings, including members of the Wick, Buechner, and Peck families. Italian immigrant stonemasons dressed and laid the ashlar for these buildings.

SOUTH SIDE UNIT OF THE YOUNGSTOWN HOSPITAL ASSOCIATION. When North Side Hospital opened in the 1920s, City Hospital changed its name to South Side Hospital. Both health care facilities were a part of the Youngstown Hospital Association until the late 20th century.

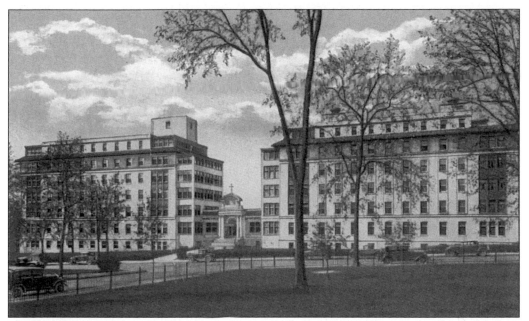

ST. ELIZABETH HOSPITAL. In 1911, the sisters of the Humility of Mary opened Youngstown's first Catholic hospital on the city's north side. Now a part of Humility of Mary Health Partners, St. Elizabeth's has grown into a major medical facility. The sisters who still run the hospital system maintain their order's commitment to caring for the sick.

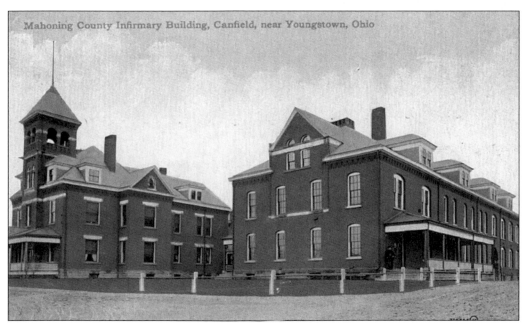

Mahoning County Infirmary Building, Canfield, near Youngstown, Ohio

MAHONING COUNTY INFIRMARY BUILDING, CANFIELD. Concerned citizens established the Mahoning County Home in 1848 to care for the aged and infirm. The Youngstown firm of Owsley and Boucherele designed the facility in the early 20th century.

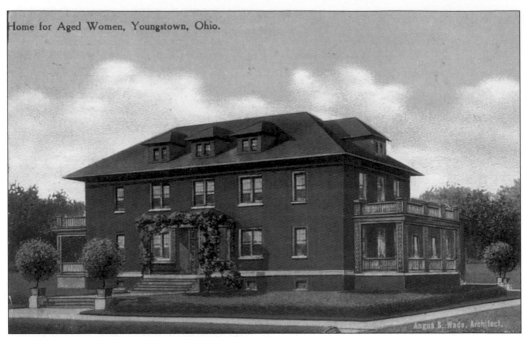

Home for Aged Women, Youngstown, Ohio.

Angus B. Wade, Architect.

HOME FOR AGED WOMEN. In 1910, the Home for Aged Women opened on Youngstown's west side. This was meant to be a haven for elderly women who were infirm and had no one to care for them. This facility is still in existence at its original Mahoning Avenue location and is now known as Paisely House.

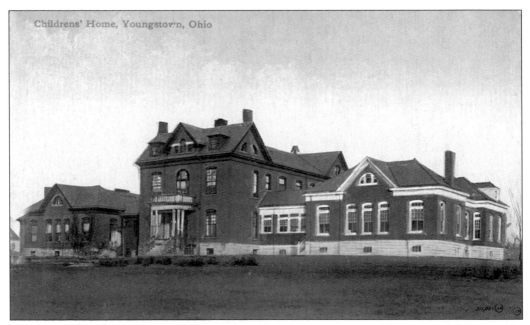

Childrens' Home, Youngstown, Ohio

CHILDREN'S HOME. Located on Glenwood Avenue on the southwest side of the city, the Children's Home provided for those youngsters who had no adults to care for them. This particular facility was built around 1900.

ODD FELLOWS BUILDING. In the early 20th century, Youngstown, like many other communities, had numerous fraternal organizations including the Odd Fellows, Masons, Elks, Moose, Rotary, and Kiwanis. The Youngstown Odd Fellows building was located at 117 W. Boardman Street in downtown.

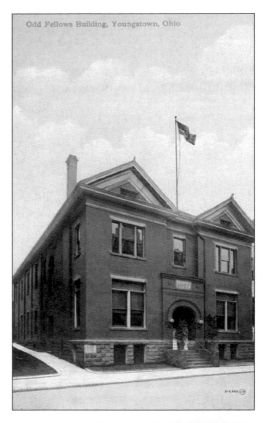

Odd Fellows Building, Youngstown, Ohio

THE ARMORY. Many cities built armories in the early 20th century, often to house the local National Guard unit. They were sometimes constructed in the wake of labor violence as an indicator to unions that they were not welcome. Youngstown's Armory was erected *c.* 1920, only a short time after the industry-wide steel strike in 1919.

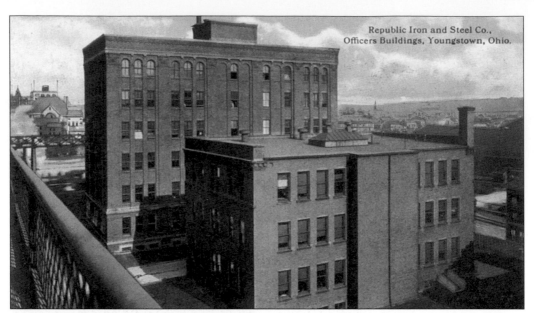

REPUBLIC IRON AND STEEL OFFICE BUILDINGS. Incorporated in 1899, the Republic Iron and Steel Company (later Republic Steel) moved its headquarters from Pittsburgh to Youngstown in 1911. By the 1930s, Republic incorporated a number of Mahoning Valley operations including Trumbull Steel in 1912, Truscon Steel in 1918, and the Trumbull-Cliffs Furnace in 1932.

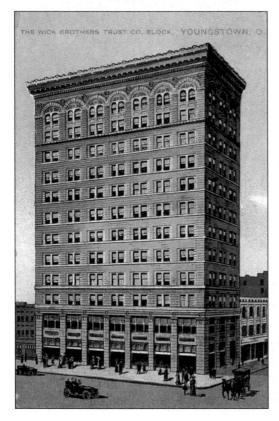

THE WICK BROTHERS TRUST CO. BLOCK, YOUNGSTOWN, O.

THE WICK BROTHERS TRUST CO. BLOCK. The Wicks were one of Youngstown's leading families. They were involved in a number of enterprises, including the iron and steel industry, banking and real estate. This skyscraper housed many of their business interests.

THE WICK BUILDING. One of Youngstown's earliest skyscrapers, constructed in 1909, the Wick Building was designed by famous Chicago architect Daniel Burnham. With his partner John W. Root, Burnham gained international recognition for his grand plans as the lead architect of the 1893 World's Columbian Exposition in Chicago. The Cambria Steel Company of Johnstown, Pennsylvania furnished and erected the structural steel for the Wick Building.

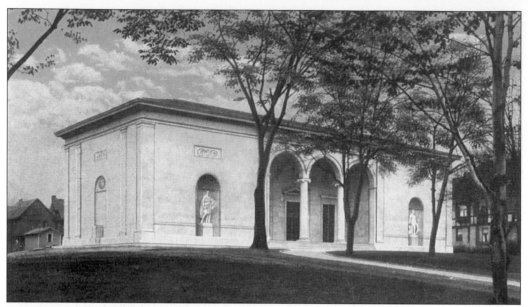

BUTLER ART INSTITUTE. Youngstown industrialist Joseph G. Butler founded the first museum dedicated solely to American Art in 1919. Butler hired the renowned New York architectural firm of McKim, Mead and White to design the building to house his collection. The architects based their Second Renaissance Revival design for the Butler on the Invalid Hospital in Florence, Italy.

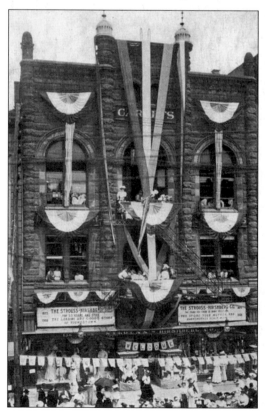

YOUNGSTOWN'S BUSY STORE—OLD HOME WEEK. The Strouss-Hirshberg Department store was originally located at 132-136 West Federal Street when Isaac Strouss and Bernard Hirshberg formed the company in 1874. Charles H. Owsley designed the building seen here. In 1926, the company moved to a new, larger building one block east on Federal, between the Wick and Union National Bank Buildings.

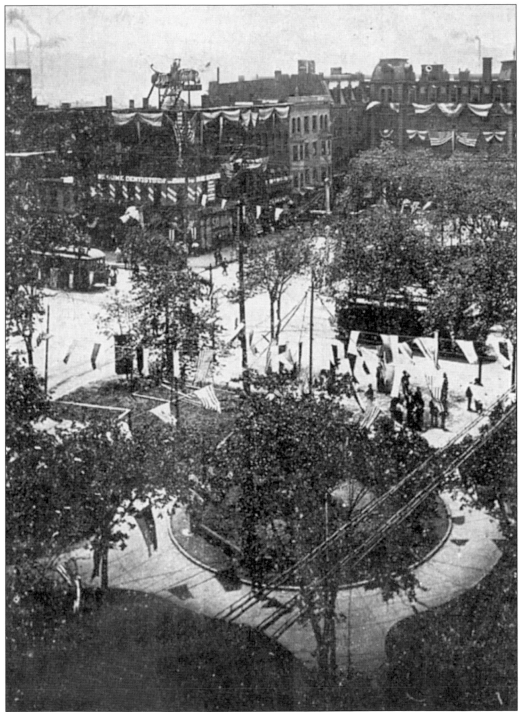

OLD HOME WEEK, CENTRAL SQUARE LOOKING WEST. From June 9 through 11, 1908, the city of Youngstown put on a gala celebration called Old Home Week. The grand event was meant to be a homecoming for the current and former citizens of the Steel City. This view of Central Square gives some idea of the elaborate decorations that festooned the downtown.

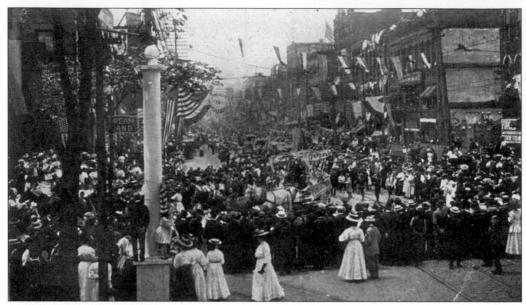

VIEWING OLD HOME WEEK PARADE. An extensive parade on June 10, 1908 marked one of the most elaborate celebrations of Old Home Week. The newspapers estimated that over 7,500 persons marched in the parade, including members of various ethnic clubs and unions as well as floats sponsored by Youngstown businesses.

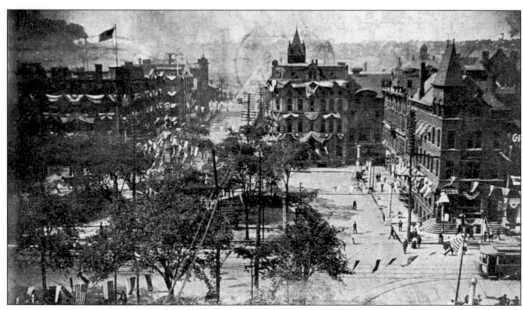

OLD HOME WEEK, CENTRAL SQUARE LOOKING SOUTH. Other events marked Old Home Week, including the Pioneer Ball, band concerts and serenades, a Mardi Gras, a grand electric illumination of downtown, and baseball games. There was even an Irish exhibit whose main feature was a map of Ireland made of sod especially imported from Eire.

Three
SACRED SITES AND MONUMENTS

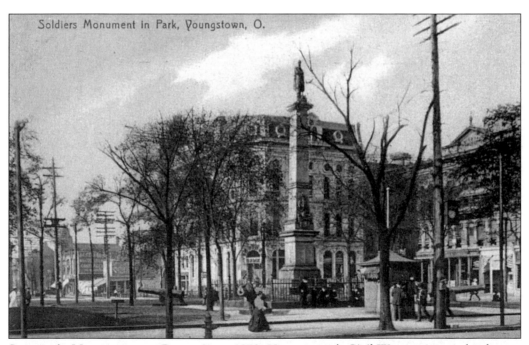

SOLDIER'S MONUMENT IN PARK. Since 1870, Youngstown's Civil War monument has been a landmark on the public square. The Union soldier at the top of the forty foot tall limestone pillar faces north. Beneath him are the names of Civil War battles where Youngstown men lost their lives. The pillar is also decorated with various patriotic symbols including flags, cannons, drums, and a stars and stripes shield.

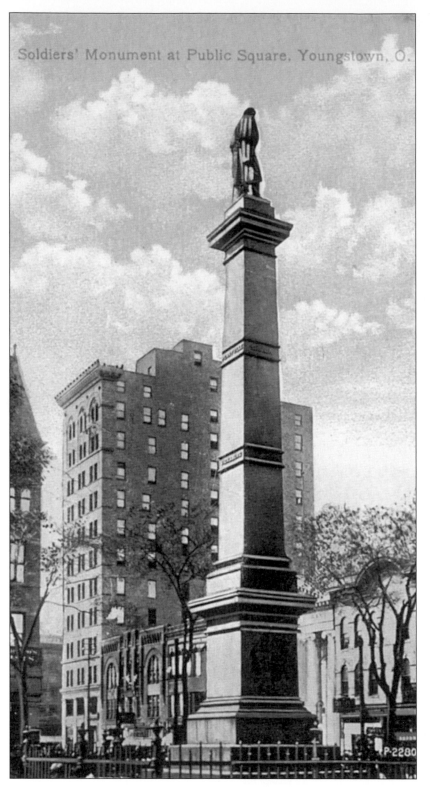

Soldiers' Monument at Public Square, Youngstown, O.

SOLDIER'S MONUMENT AT PUBLIC SQUARE. Dedicated on July 4, 1870, the "Man on the Monument" cost a total of $15,000 to erect. The inscription reads: "The Heroic Dead of Youngstown Twp., killed in battle or died from disease contracted in the army, 1861–1865," followed by the names of the deceased, "Erected by the Citizens of Youngstown in memory of the heroes of the township who gave their lives to their Country in the War of the Rebellion, 1861–1865."

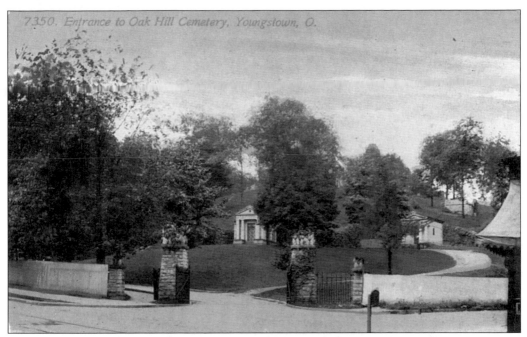

7350. Entrance to Oak Hill Cemetery, Youngstown, O.

ENTRANCE TO OAK HILL CEMETERY. Looming above Youngstown on the city's lower south side, Oak Hill Cemetery was one of the many cemeteries developed as urban memorial parks in the 19th century throughout the nation. Besides the graves of many prominent citizens, several African-American Civil War veterans are also interred here.

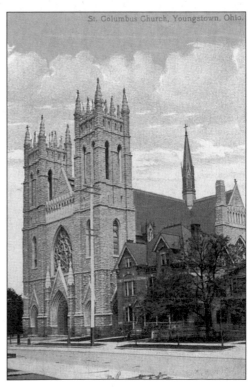

St. Columbus Church, Youngstown. Ohio.

ST. COLUMBA CHURCH. Now the cathedral church for the Roman Catholic Diocese of Youngstown, St. Columba was the first Catholic Church in Youngstown. The congregation formed in 1847 and erected their first church in 1853. The building seen here replaced the earlier church, which stood directly across the street from this site, in 1900. In the 1950s, this High Gothic Revival building burned; in its place is a modernist contemporary structure. St. Columba parish also formed the first Catholic elementary school in Youngstown in 1861.

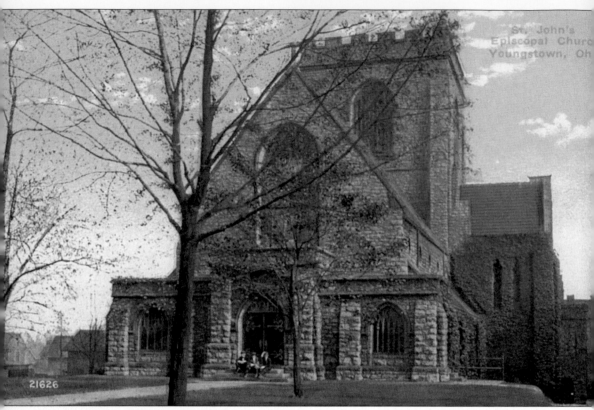

21626

ST. JOHN'S EPISCOPAL CHURCH. Located on Wick Avenue, which at one time was Youngstown's "Millionaire's Row," this church was the second for St. John's congregation. Built in 1898, the building is Norman Gothic Revival, featuring outstanding stained glass windows that depict the various processes in the manufacture of iron and steel as a tribute to the area's workers.

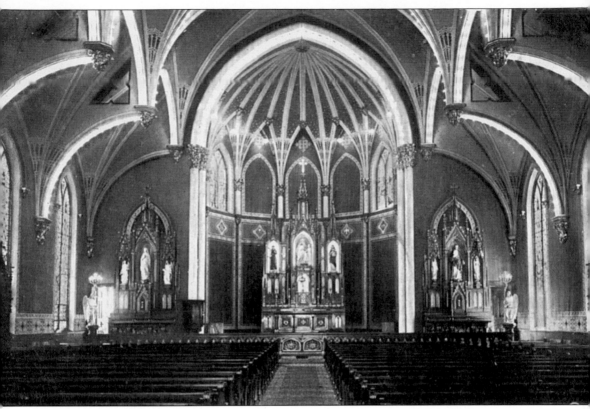

INTERIOR OF ST. ANN'S CHURCH. Located on the corner of West Federal and Jefferson Streets on the northwest side of the city, St. Ann's served the Catholic residents of the Brier Hill neighborhood. Brier Hill, which included land once owned by Ohio's Civil War governor and local iron maker, David Tod, became home to a large immigrant population in the early 20th century.

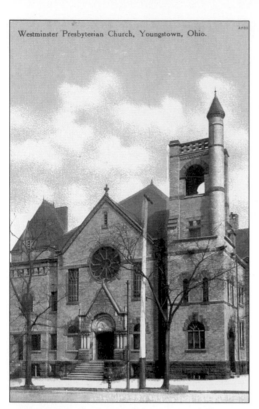

Westminster Presbyterian Church, Youngstown, Ohio.

WESTMINSTER PRESBYTERIAN CHURCH. One of the oldest congregations in Youngstown, Westminster Presbyterian Church was originally located in downtown on Market Street, across from the Mahoning County Courthouse.

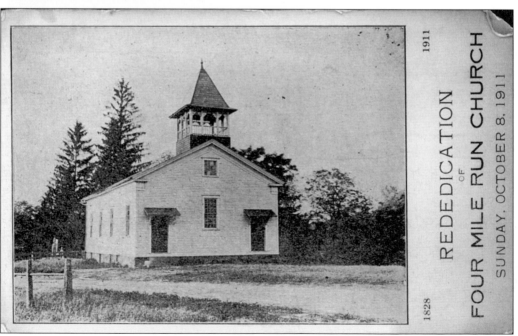

1911

REDEDICATION
OF
FOUR MILE RUN CHURCH
SUNDAY, OCTOBER 8, 1911

1828

REDEDICATION OF FOUR MILE RUN CHURCH. The Mahoning Valley not only housed impressive churches like Saint Columba's, it also included small country houses of worship such as Four Mile Run Church.

Four
TRANSPORTATION
AND INDUSTRIAL
STRUCTURES

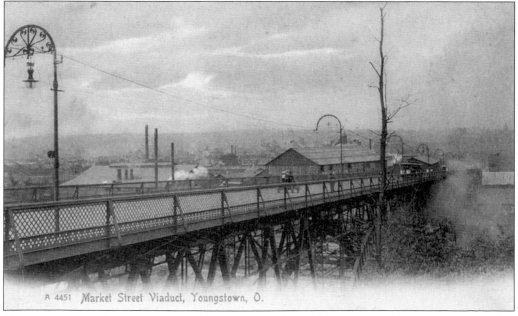

A 4451 Market Street Viaduct, Youngstown, O.

MARKET STREET VIADUCT. Completed in 1899, the Market Street viaduct was over 1600 feet long. Its opening spurred the development of Youngstown's south side (the left side of the postcard), spanning what was once called the "Impassable Ridge."

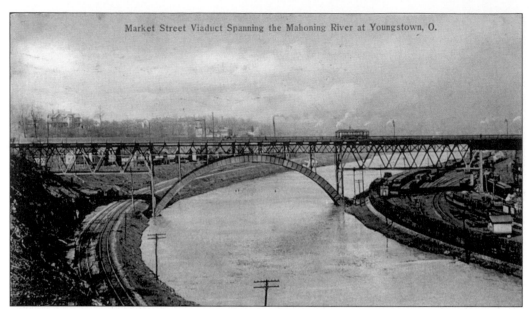

Market Street Viaduct Spanning the Mahoning River at Youngstown, O.

MARKET STREET VIADUCT SPANNING THE MAHONING RIVER. The Park and Falls Street Railway Company was influential in completing the Market Street viaduct by partly funding the project in return for the right-of-way over the bridge. The same year the Market Street viaduct opened, Park and Falls opened an amusement park at the end of its line on the south side, which it named Terminal Park. The park was renamed Idora, and remained a local institution for over 80 years.

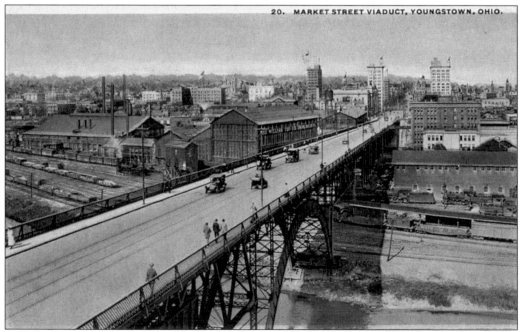

20. MARKET STREET VIADUCT, YOUNGSTOWN, OHIO.

MARKET STREET VIADUCT. This is a slightly later image of the Market Street bridge, which is looking north into downtown. The heavy industry that supported the Mahoning Valley is seen in the factory buildings on either side of the span.

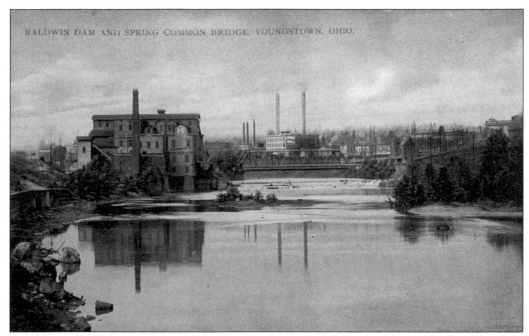

BALDWIN DAM AND SPRING COMMON BRIDGE. Homer Baldwin ran a successful gristmill along the Mahoning River near downtown. The mill is on the left; the dam supported the work of grinding the grain for sale as flour, which produced over 500 barrels daily.

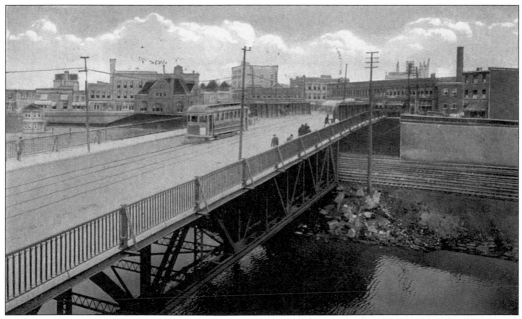

SPRING COMMON BRIDGE. The Mahoning River, which was so important to the Mahoning Valley's iron and steel industry, was also an impediment to development of the south and west sides of the city. As early as 1830, a bridge spanned the river at the site known as Spring Common. The bridge seen here dates from 1911.

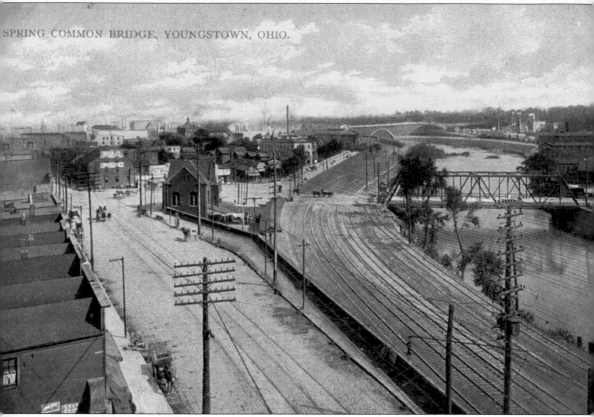

SPRING COMMON BRIDGE, YOUNGSTOWN, OHIO.

SPRING COMMON BRIDGE. Spring Common was the site where John Young, an employee of the Connecticut Land Company, founded the city that was named for him in 1796. Ironically, he never put down roots in the Steel City. However, James Hillman and Daniel Shehy, who accompanied Young, did settle in Young's tiny village along the Mahoning River.

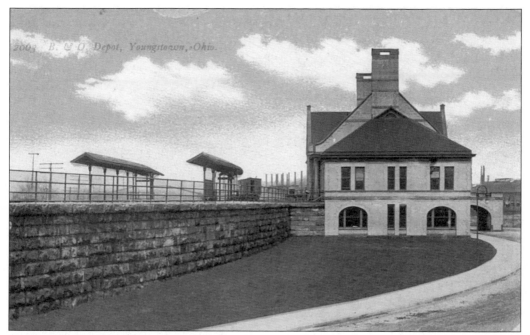

B&O DEPOT. Opened in 1905, this Georgian Revival train station served both passengers and freight for the Baltimore and Ohio Railroad. It replaced an earlier station located further east along the Mahoning River, under the Market Street bridge.

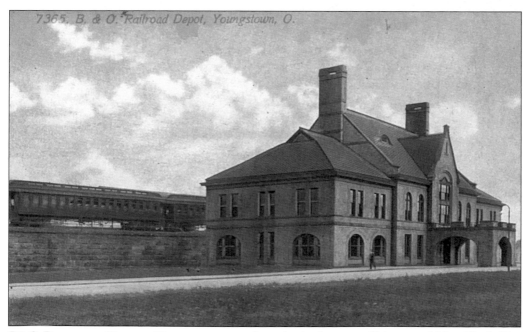

B&O RAILROAD DEPOT. Youngstown was the only city between Chicago and New York City where the nation's four largest railroad lines—the Pennsylvania, Baltimore and Ohio, New York Central, and Erie—all converged.

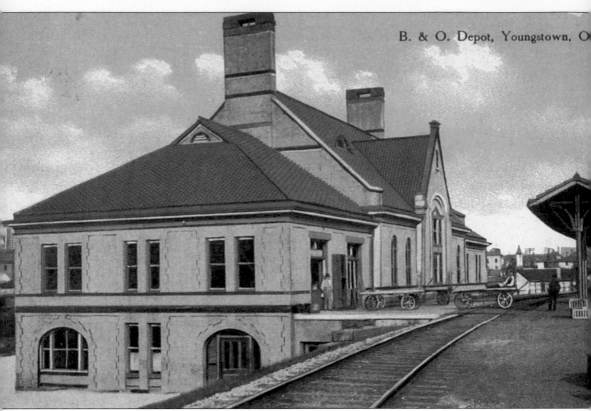

B&O DEPOT. Located half way between Chicago and New York City, as well as Cleveland and Pittsburgh, Youngstown was ideally placed to be a major transportation center. Couple this with the city's growing importance as a leader in manufacturing and it is no wonder so much of the nation's transportation network passed through here.

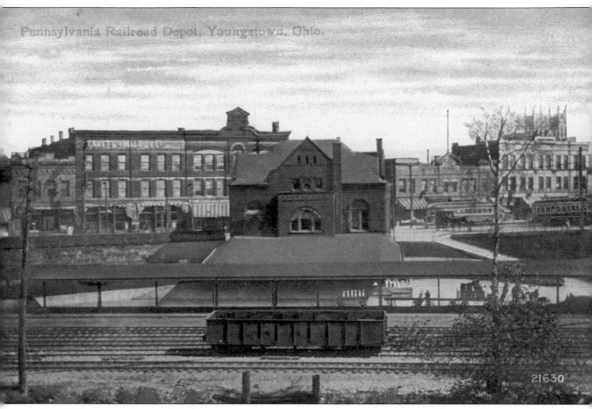

Pennsylvania Railroad Depot, Youngstown, Ohio.

21630

PENNSYLVANIA RAILROAD DEPOT. Located at the western edge of downtown Youngstown on W. Federal Street, the Pennsylvania Railroad Depot was one of four large stations serving the area. Of the four, only the B&O Station and the Erie Terminal remain.

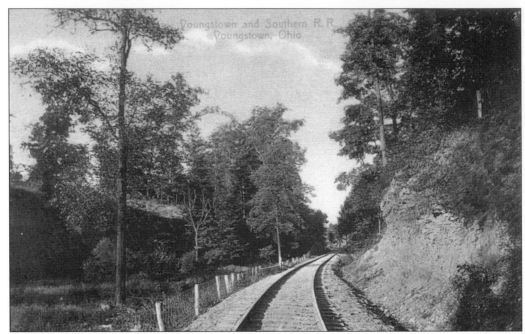

YOUNGSTOWN AND SOUTHERN RR. In 1903, the Youngstown and Southern Railway completed its line from the city of Youngstown south to Columbiana County. The interurban allowed people with means to live further away from the smoky, congested inner city. It also gave rural dwellers an opportunity to visit the "big city" and participate in the benefits of urban life.

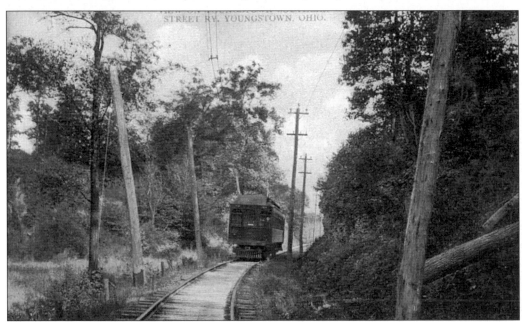

VIEW ON YOUNGSTOWN SOUTHERN STREET RAILWAY. Along with the Park and Falls Street Railway, the Youngstown and Southern Street Railway helped spur the development of the south side of Youngstown. A number of "street car suburbs" sprang up on the city's upper south side as well as in Boardman Township, just south of Youngstown.

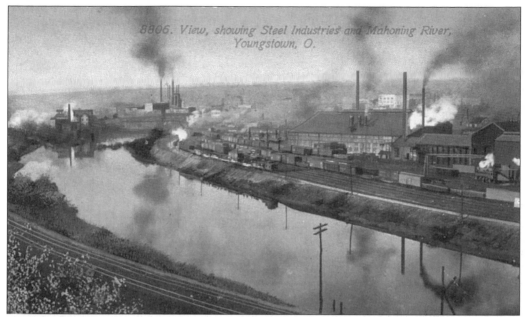

VIEW SHOWING STEEL INDUSTRIES AND MAHONING RIVER. In the early 20th century, the Mahoning Valley was second only to Pittsburgh, Pennsylvania in the tonnage of pig iron produced annually. The mills lined both sides of the Mahoning River from Warren on the north end to Lowellville on the south.

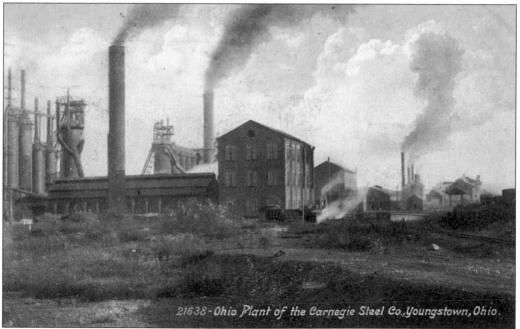

OHIO PLANT OF THE CARNEGIE STEEL CO. U. S. Steel became the world's first billion dollar corporation in 1901. The steel making giant was the result of a merger between J. P. Morgan's Federal Steel with Andrew Carnegie's Carnegie Steel. Eight major and a significant number of smaller firms comprised the new company.

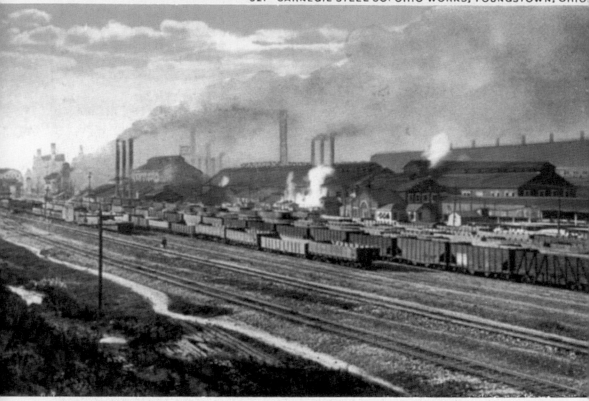

CARNEGIE STEEL CO. OHIO WORKS. One of the eight major firms that became a part of U.S Steel was National Steel. Around 1896, National Steel purchased the Youngstown based Ohio Steel Company. The latter formed in 1892 and three years later poured the first Bessemer process steel in the Mahoning Valley. With the merger, the Youngstown plant was known as the Ohio Works of Carnegie Steel.

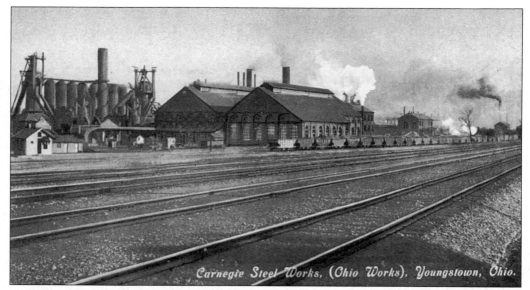

Carnegie Steel Works, (Ohio Works), Youngstown, Ohio.

CARNEGIE STEEL WORKS (OHIO WORKS). Youngstown's Ohio Works of Carnegie Steel also included the Upper and Lower Union Mills. The Upper Union Mill merged with the Youngstown Iron Company in 1892 and changed its name to the Union Iron and Steel Company. In 1899, National Steel added the Upper and Lower Union Mills to its fold, which it ran under the name of the American Steel Hoop Company.

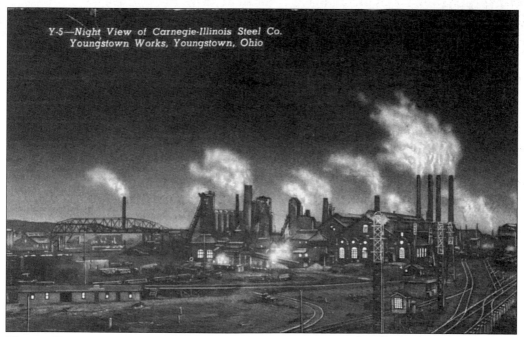

Y-5—Night View of Carnegie-Illinois Steel Co. Youngstown Works, Youngstown, Ohio

NIGHT VIEW OF THE CARNEGIE ILLINOIS STEEL CO. YOUNGSTOWN WORKS. The Youngstown plant was a part of the Carnegie-Illinois Steel division of U.S. Steel. Besides the fully integrated mill the company owned in Youngstown, U.S. Steel also built finishing mills further up the Mahoning River in 1917. To support the new plant, the company also built the town adjacent to the mills, which it named McDonald.

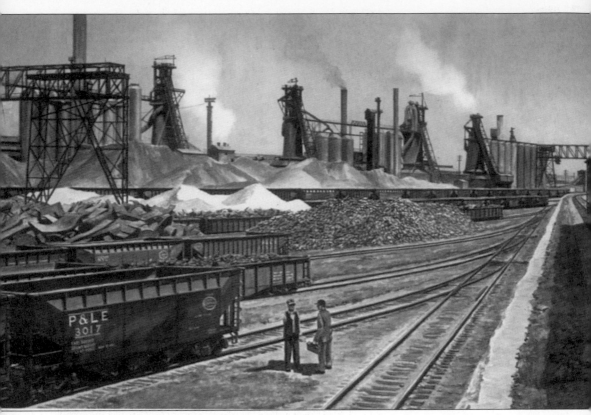

YOUNGSTOWN STEEL MILL. While this postcard does not indicate which steel company is depicted here, it does show one of the major parts of the steel making process. In the background there are four tall stacks, which are the blast furnaces. It is here that iron ore is smelted and becomes pig iron. In the foreground are railroad cars and piles of slag, which is the waste product from the blast furnaces.

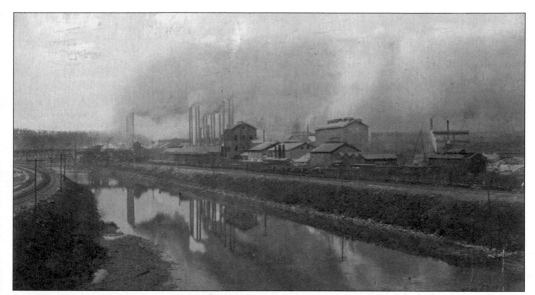

BESSEMER STEEL PLANT OF THE REPUBLIC IRON AND STEEL COMPANY. Formed in 1899, Republic Iron and Steel moved its headquarters to Youngstown in 1911. In Youngstown, Republic bought out the old Brown-Bonnell Company, originally known as the Youngstown Iron Company. Renamed the Republic Steel Corporation in 1930, industrialist Cyrus Eaton merged a number of smaller companies into this large conglomerate. Republic also owned a fully integrated steel mill in Warren, Ohio, which is now known as WCI Steel. Truscon Steel became a part of Republic in 1928 and had a plant on Youngstown's east side.

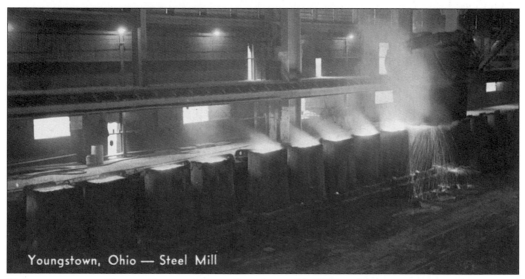

YOUNGSTOWN, OHIO STEEL MILL. By the mid-1920s, there were three large steel manufacturers in Youngstown: Republic Iron and Steel, Carnegie Steel, and the Youngstown Sheet and Tube Company. The only locally owned concern, Sheet and Tube, incorporated in 1900 and opened its first plant in East Youngstown (now Campbell) the following year. In 1923, Sheet and Tube purchased the Brier Hill Steel Company on the city's northeast side. At one point, Sheet and Tube was one of the largest employers in the state of Ohio and eighth largest steel company in the nation.

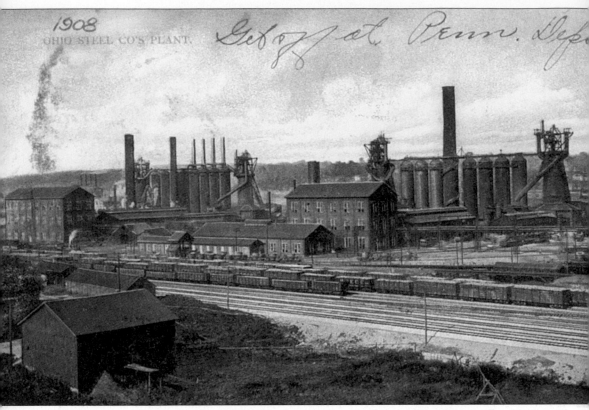

1908
OHIO STEEL CO'S PLANT.

OHIO STEEL CO.'S PLANT. Although the post card refers to this plant as the Ohio Steel Company, it is really the Ohio Works of the Carnegie Steel Company. The plant's four blast furnaces and stoves, which heat the air for the furnaces, are graphic reminders of this great industry's legacy in the Mahoning Valley.

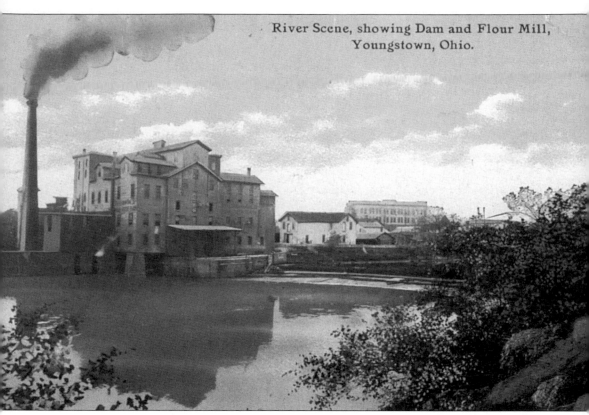

River Scene, showing Dam and Flour Mill, Youngstown, Ohio.

RIVER SCENE, SHOWING DAM AND FLOUR MILL. Besides providing a much needed water supply for the iron and steel mills, the Mahoning River was also important to other local industries, such as the Baldwin Grist Mill, seen here.

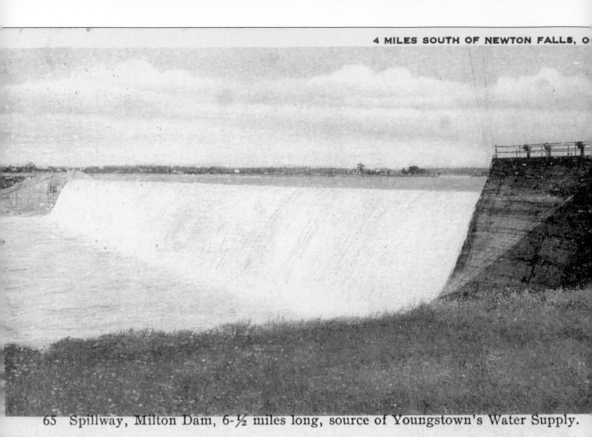

65 Spillway, Milton Dam, 6-½ miles long, source of Youngstown's Water Supply.

SPILLWAY, MILTON DAM. Youngstown's rapidly increasing population in the early 20th century necessitated new sources of water supply. In 1916, the city completed a dam in Milton Township, in southwest Mahoning County. The dam created Lake Milton, which is now used as a recreational lake.

Five

HOTELS AND
RESTAURANTS

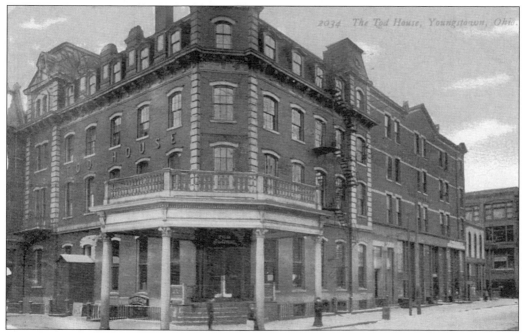

THE TOD HOUSE. From the mid–19th to mid–20th century, the Tod House hotel dominated Youngstown's public square. This is the original hotel, which is in the French Second Empire style; the chief bricklayer was African-American P. Ross Berry.

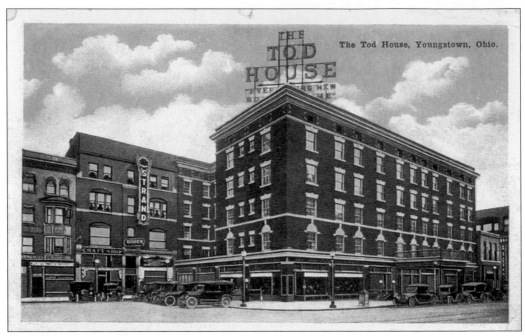

THE TOD HOUSE. Although it was razed in the 1960s, the Tod House was a long standing Youngstown hotel. The building seen here replaced the 19th century structure *c.* 1910.

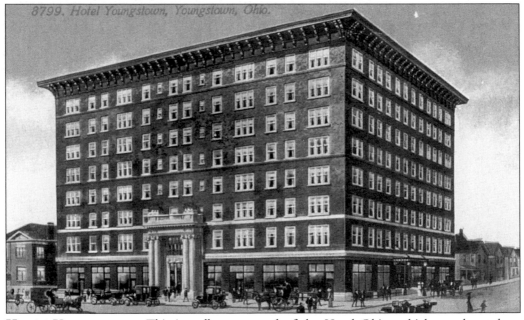

HOTEL YOUNGSTOWN. This is really a postcard of the Hotel Ohio, which was located on Boardman Street in downtown Youngstown.

HOTEL OHIO. Later known as the Hotel Pick-Ohio, this Neo-Classical Revival structure was one of the finest hostelries in the city. Built in 1911, the hotel was known for its fantastic lobby murals, which extended through to the second floor.

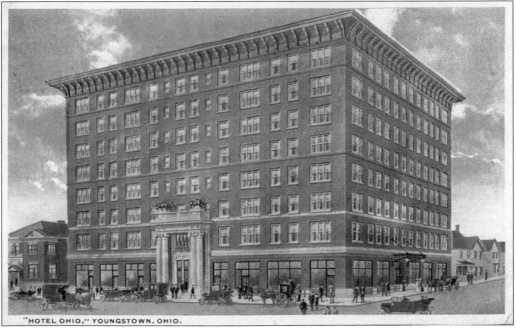

"HOTEL OHIO," YOUNGSTOWN, OHIO.

HOTEL OHIO. The Hotel Ohio was famous for its hospitality and service. The building is still standing, but it now is owned by the Youngstown Metropolitan Housing Authority, and is a senior citizens residence as well as the agency's headquarters. YMHA remodeled the building in 2002.

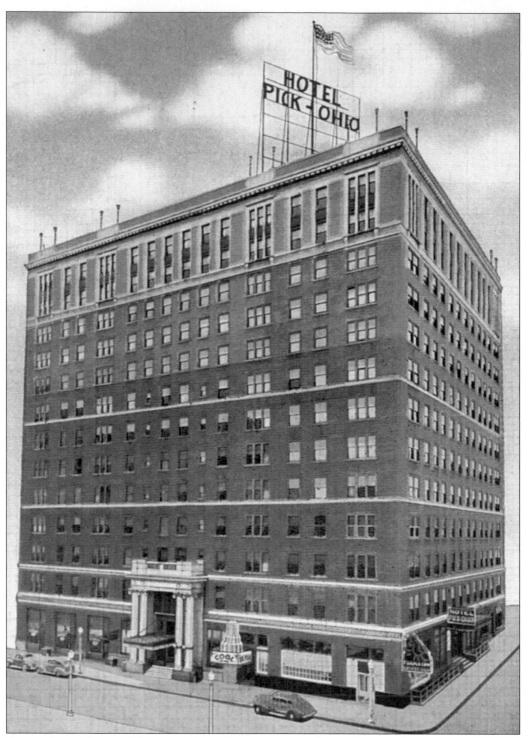

HOTEL PICK-OHIO. The Hotel Ohio became a part of the Albert Pick Hotel chain around 1940. Four stories were added to increase the size of the structure. The building had 400 rooms, convention and banquet facilities and an outstanding, elegant ballroom.

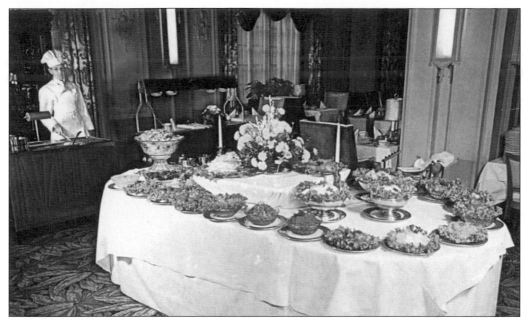

CRYSTAL DINING ROOM, HOTEL PICK-OHIO. The Crystal Dining Room was one of the finest restaurants in the city. The dinner banquet shown in the postcard gives an idea of the kind of lavish entertainment provided by this facility.

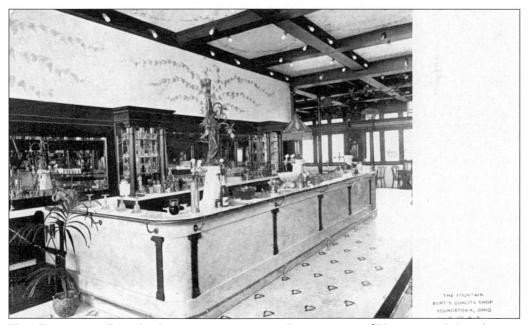

THE FOUNTAIN, BURT'S QUALITY SHOP. Harry Burt was one of Youngstown's best-known manufacturers and purveyors of confectionary treats, baked goods and ice cream. His original shop was located downtown at 25 N. Phelps Street.

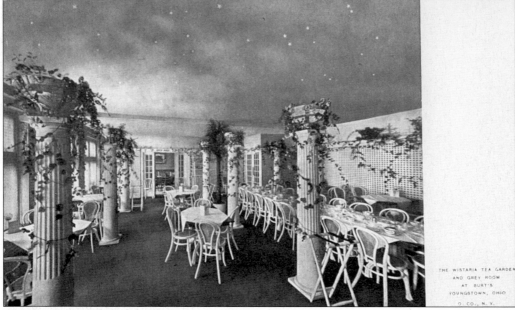

THE WISTERIA TEA GARDEN AND GREY ROOM AT BURT'S. Harry Burt's major claim to fame is as the inventor of the Good Humor Bar. Burt was trying to improve upon the messy Eskimo Pie by adding a stick to the bar of chocolate-coated ice cream. In 1923, he received the patent for his idea.

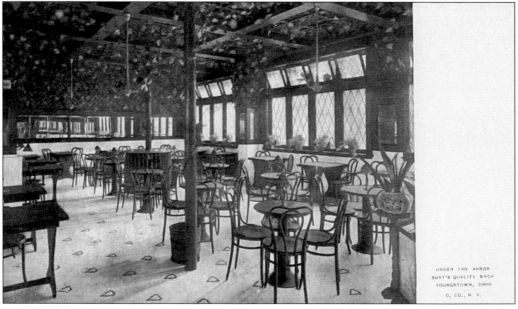

UNDER THE ARBOR, BURT'S QUALITY SHOP. Not only did Harry Burt sell his new treat in his restaurant and stores, he also sold the bars from trucks that traveled through Youngstown's neighborhoods, becoming familiar summertime fixtures. After Burt's death in 1926, the family sold the company to a Cleveland-based firm, which renamed the business the Good Humor Company of America.

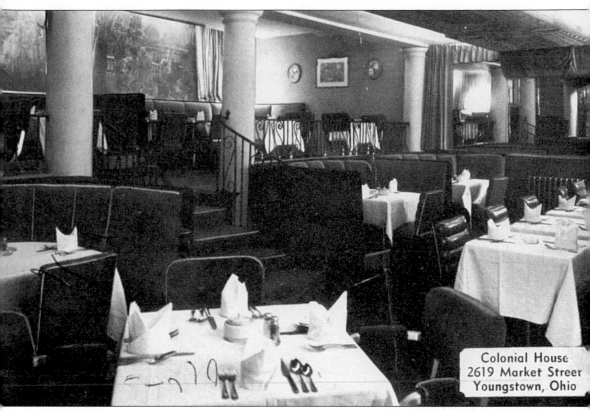

Colonial House
2619 Market Street
Youngstown, Ohio

COLONIAL HOUSE. One of Youngstown's finest restaurants, the Colonial House was located in the area known as the Uptown on the city's south side. The restaurant was located in an old Colonial Revival mansion—hence its name; it opened in the late 1950s.

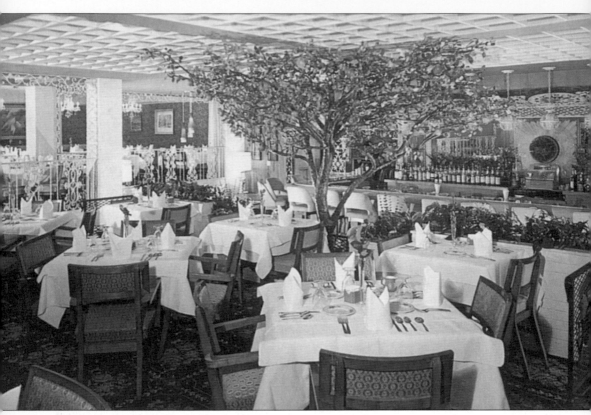

CICERO'S RESTAURANT. Nearly adjacent to the Colonial House on Market St. stood another outstanding Youngstown restaurant—Cicero's. It was fairly short-lived, opening in the early 1960s and closing less than ten years later.

Six
THE MAHONING RIVER AND MILL CREEK PARK

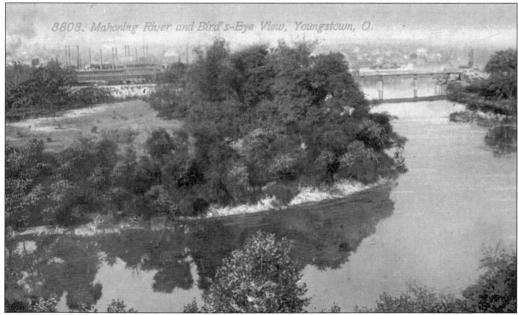

MAHONING RIVER AND BIRD'S-EYE VIEW. Since the beginning of European settlement in what are now Mahoning and Trumbull Counties, the Mahoning River has been the life's blood of the communities lining its shores. At first a source of drinking water and means of transportation, the Mahoning River and its tributaries later became major players in the burgeoning iron and steel industry. While this image portrays a relatively quiet, almost bucolic stream, the smokestacks in the background give the viewer a small hint of the river's important role in industrial development.

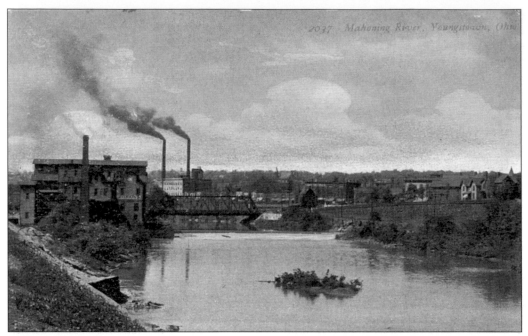

MAHONING RIVER. The Mahoning River has played a pivotal role in the life of the communities through which it flows. Without the river, there would have been no iron and steel mills. As the ferrous industries grew and spread along the river's banks, jobs to make these industries run attracted new people to the Mahoning Valley.

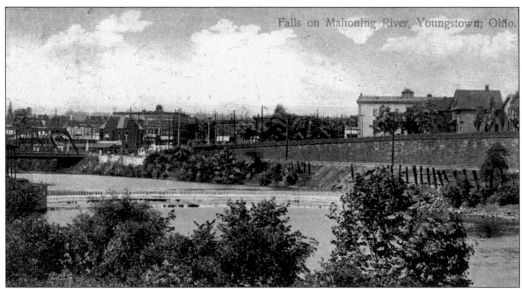

FALLS ON MAHONING RIVER. The first settlers came from older states like New York and Connecticut. Immigrants from the British Isles and northern Europe soon joined them. By the beginning of the 20th century, about the time that Youngstown mills produced their first Bessemer process steel, newcomers from southern and eastern Europe flocked to the Mahoning Valley, giving the area its distinctive ethnic flavor. Later, African-Americans and Hispanics also came seeking work in the mills.

78

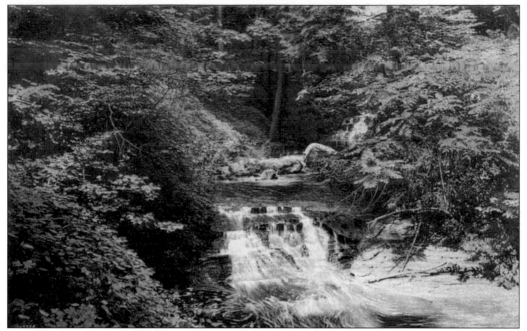

BEAR'S DEN CASCADES. Volney Rogers, the father of Mill Creek Park, was born in Columbiana County in 1846. After being admitted to the Ohio bar, Rogers moved to the growing city of Youngstown in 1872 to practice law. Over time, he grew involved in helping to make his adopted home a good place to live. Rogers' concern for Youngstown and his interest in concepts such as the City Beautiful Movement manifested itself in the development of Mill Creek Park.

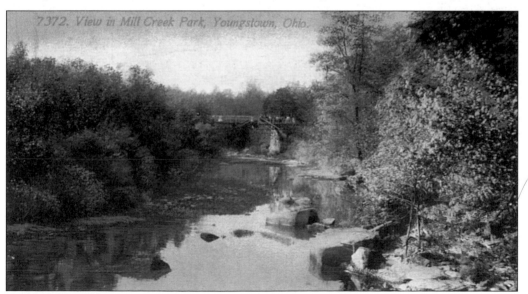

VIEW IN MILL CREEK PARK. America's most prominent landscape architect in the 19th century was Frederick Law Olmsted. Rogers admired Olmsted's work in creating urban parks such as Central Park and tried to hire him to develop Mill Creek Park. Olmsted, however, was busy working on his designs for the 1893 World's Columbian Exposition in Chicago. Instead, Rogers hired one of Olmsted's students, Charles Eliot, as a consultant.

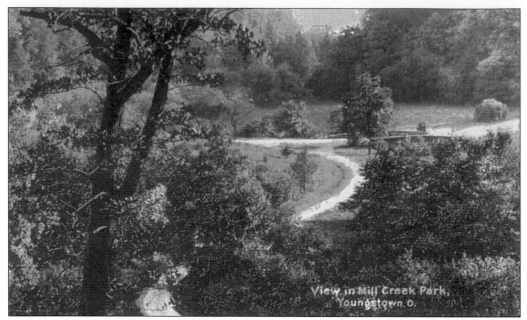

VIEW IN MILL CREEK PARK. Rogers joined the American Civic Association, a national organization dedicated to making urban areas comfortable and attractive places to live. The ACA was particularly interested in conservation of natural spaces, which reflected Rogers' own views. His concern for the environment was one of the driving forces behind the creation of Mill Creek Park.

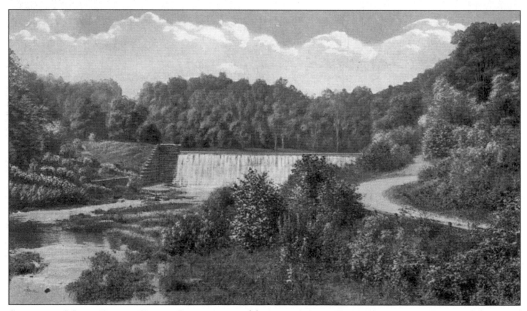

SCENE IN MILL CREEK PARK. Rogers was able to convince Youngstown tax payers of the need to preserve the beauty of the Mill Creek gorge. In 1891, Mill Creek Park became Ohio's first municipal park system.

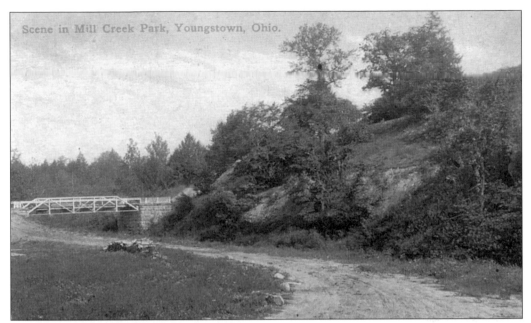

SCENE IN MILL CREEK PARK. During the first eight years of Mill Creek Park's existence, Rogers and the park board were faced with the problem of getting visitors to the site. It was not until 1899, with the opening of the Market Street viaduct that trolley service—provided by the Park and Falls Street Railway Company—made the park accessible to a majority of Youngstown's population.

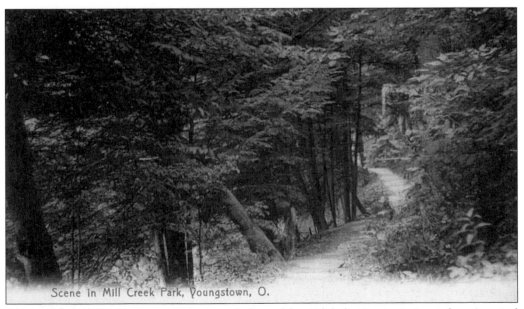

SCENE IN MILL CREEK PARK. This tranquil view of the park belies its proximity to the gritty steel mills that dominated the Mahoning Valley in the early 20th century. As Rogers' biographer, Bridget Williams noted, Rogers believed that Mill Creek's bucolic setting would relax workers after a hard day at the mill and make them less prone to drunkenness and disorderly conduct. He was not unique in the belief; many who supported the development of urban parks would have agreed with Rogers.

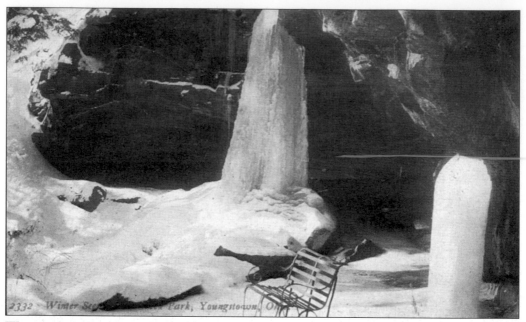

WINTER SCENE IN MILL CREEK PARK. In the winter, Mill Creek Park took on an almost eerie quality as depicted here.

LAKE SCENE NEAR YOUNGSTOWN, OHIO. Although not identified as such, this image depicts one of the lakes in Mill Creek Park.

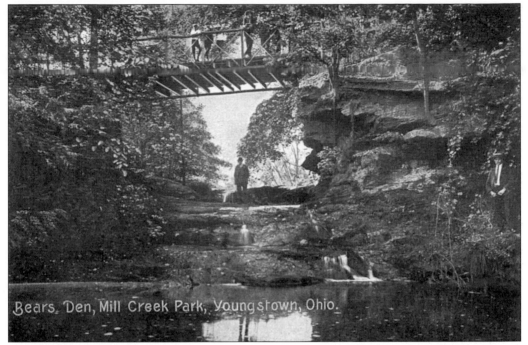

Bears Den, Mill Creek Park, Youngstown, Ohio.

BEARS DEN, MILL CREEK PARK. Volney Rogers added the land known as Bears Den to the park's acreage in 1894. Located in the western end of the park, there was no direct connection between the core of the park and Bears Den until 1921. The area gets its name because at one time this rugged ravine was a natural haven for bears.

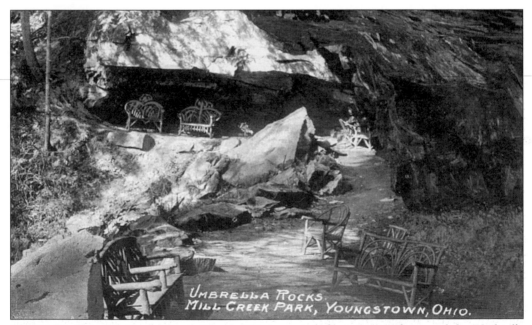

UMBRELLA ROCKS.
MILL CREEK PARK, YOUNGSTOWN, OHIO.

UMBRELLA ROCKS, MILL CREEK PARK. This large rock formation, aptly named the Umbrella Rocks, provides a natural shelter for park visitors. In the park's early years, the commissioners provided seating for weary hikers.

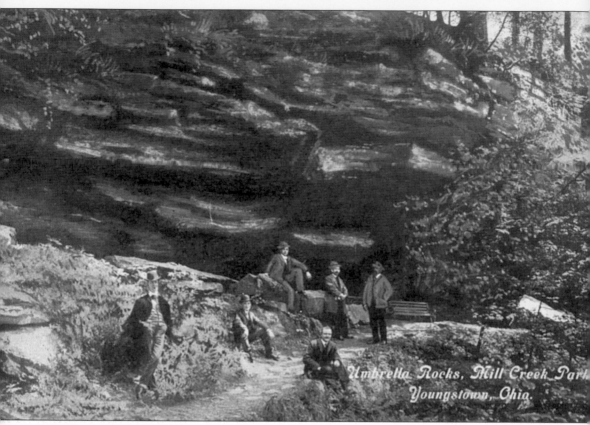

UMBRELLA ROCKS, MILL CREEK PARK. The Umbrella Rocks are located in a section of the park known as the "Gorge." Nearby the formation is a ravine, where a steady stream of water from Idora Park, the amusement park adjacent to Mill Creek, caused erosion.

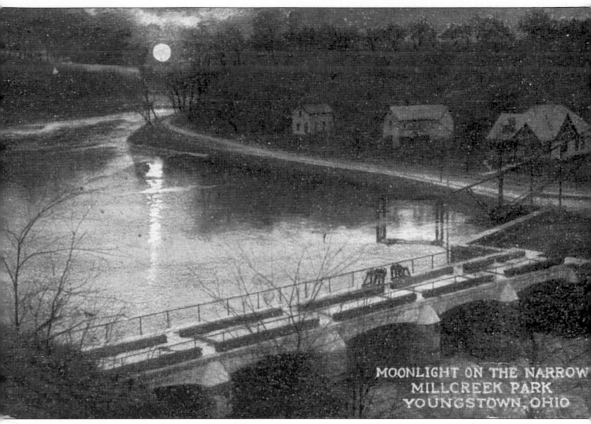

MOONLIGHT ON THE NARROW
MILLCREEK PARK
YOUNGSTOWN, OHIO

MOONLIGHT ON THE NARROWS, MILL CREEK PARK. This nighttime view shows the northernmost point of Mill Creek Park. Built between 1904 and 1906, the dam in the foreground was meant to contain the waters of Mill Creek as it wended its way to the Mahoning River.

WALK IN MILL CREEK PARK. The wild beauty of many places in the park is evident in this image.

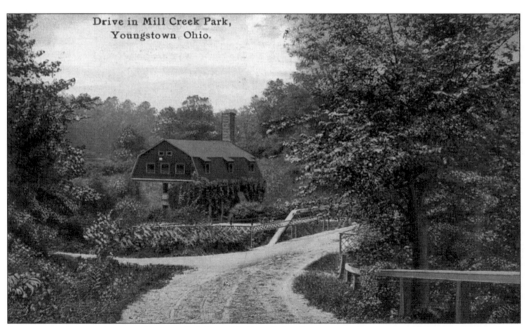

DRIVE IN MILL CREEK PARK. While Mill Creek Park was meant to give visitors a hint of the wilderness, drives through the park eventually permitted automobile traffic. This alone speaks volumes for the pervasive influence of the "horseless carriage" even at an early date.

MILL CREEK PARK. The trend toward urban parks began in the early 19th century. Park-like cemeteries, such as Mt. Auburn in Boston and Spring Grove in Cincinnati, were early manifestations of the desire to retain green spaces within city limits. By the end of the century, parks appeared in cities throughout the nation, following the lead of New York City's Central Park.

OLD STAGE ROAD, MILL CREEK PARK. Volney Rogers tirelessly worked to keep Mill Creek Park safe, clean, and free of industries. He believed that the park should forever be a healthful and beautiful source of recreation for the citizens of the Mahoning Valley.

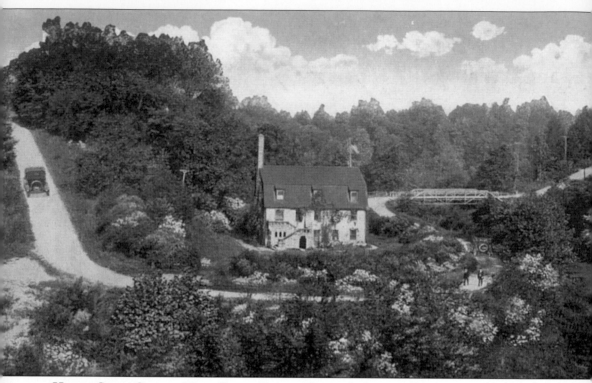

HORSE SHOE CURVE, MILL CREEK PARK. The roads that wend their way through the park are curvilinear, to give the visitor a feeling of being in a rural setting. There are several hairpin turns throughout the park's byways such as the one pictured here.

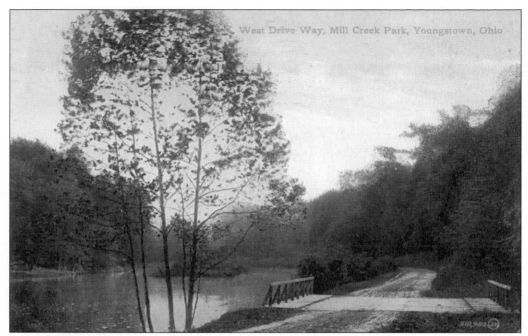

WEST DRIVE WAY, MILL CREEK PARK. Most of the park's drives are named; the direction usually indicates on which side of the Mill Creek gorge the drive is located.

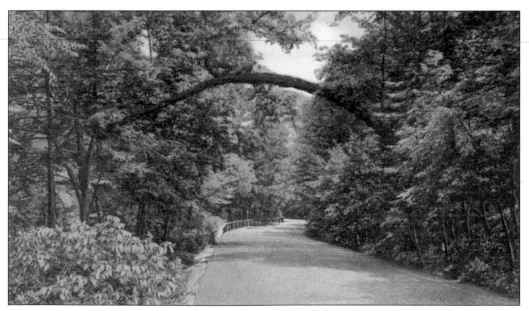

ARCH TREE AND DRIVE, MILL CREEK PARK. Located along East Park Drive, the Arch Tree is only a memory seen in postcards such as this.

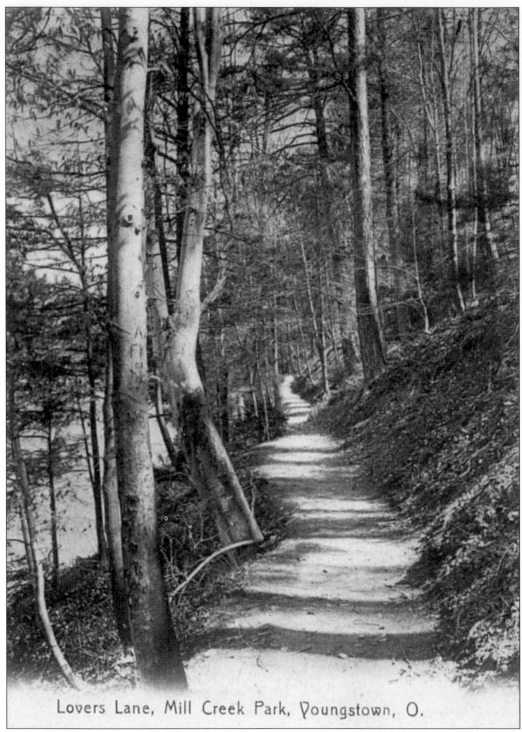

Lovers Lane, Mill Creek Park, Youngstown, O.

LOVER'S LANE, MILL CREEK PARK. No park was complete without lovely walks where couples could spend quiet times together. "Lover's Lane" at Mill Creek Park could easily be applied to any of the walking trails throughout the site.

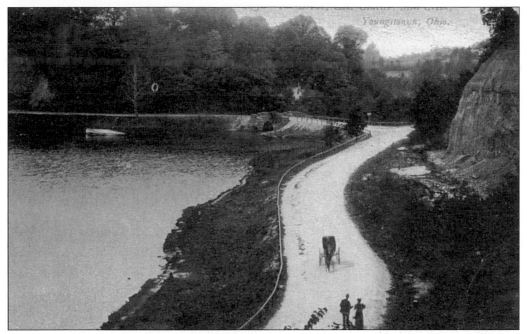

THE DRIVE, LAKE GLACIER, MILL CREEK PARK. Winding along Lake Glacier, this drive afforded visitors a view of the lake, the dam, trees, and rock formations. Even in the 21st century, park goers still travel along the banks of the park's lakes.

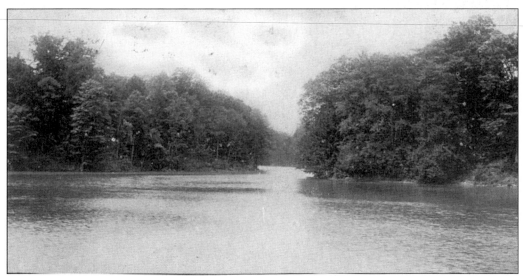

LAKE COHASSET, MILL CREEK PARK. This is a 1906 view of Lake Cohasset, the first lake created in the park. Cohasset, which sits just south of Lake Glacier, was completed in 1897. Its name is supposedly an Indian word meaning "place of hemlocks" or "place of pines."

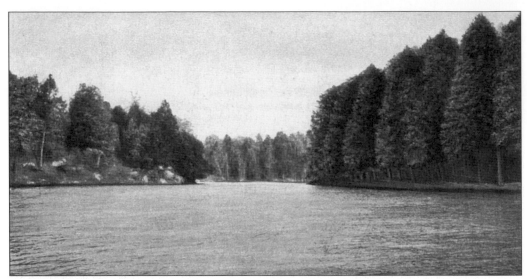

LAKE COHASSET, MILL CREEK PARK. Mill Creek's water supply became a political football within Youngstown, as the city sought new sources of drinking water for the growing community. Volney Rogers fought tenaciously to keep the new park's lakes and streams as sources of recreation.

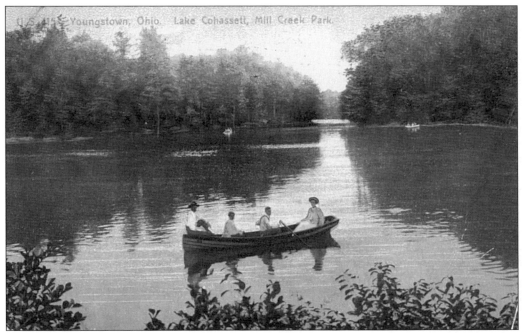

LAKE COHASSET, MILL CREEK PARK. The arguments for tapping into Mill Creek's water was its pure quality. The Mahoning River was growing more polluted by the day as a receptacle for industrial and human waste.

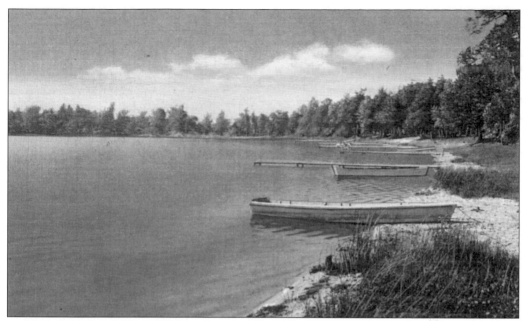

LAKE COHASSET, MILL CREEK PARK. The Mahoning River's pollution, even as early as the 1890s, resulted in a high incidence of typhoid in Youngstown. In 1901, a "workman" wrote to the *Vindicator*, one of the city's two daily newspapers, that if the Mill Creek was utilized as the water commissioners suggested, "we will finally be away from the filthy river for the water supply."

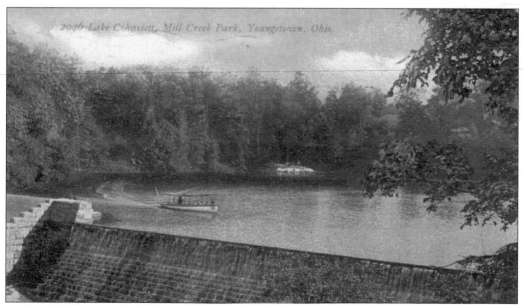

LAKE COHASSET, MILL CREEK PARK. While the debate over Mill Creek's water raged for most of the first decade of the 20th century, the popularity of the lakes for recreational purposes grew. Eventually, the Meander Reservoir, located west of the city, became the new source of potable water.

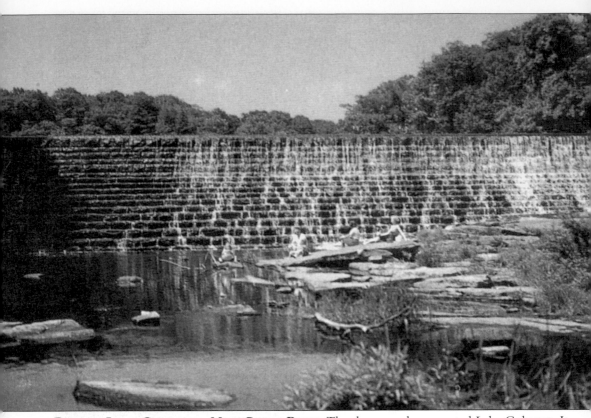

DAM AT LAKE COHASSET, MILL CREEK PARK. The dam seen here created Lake Cohasset. It is 147 feet wide and made of stone from a Mill Creek Park quarry.

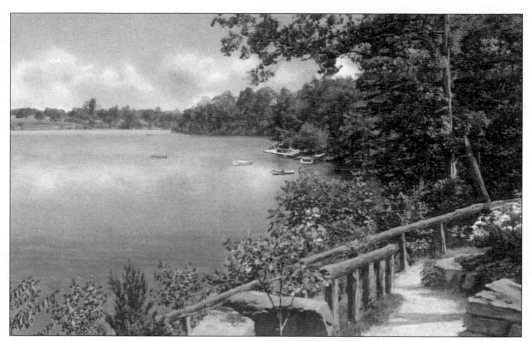

LAKE AT MILL CREEK PARK. A number of walking trails border the park's lake, offering hikers an entrancing and calming vista. Rogers intended the lakes to have over one hundred scenic views.

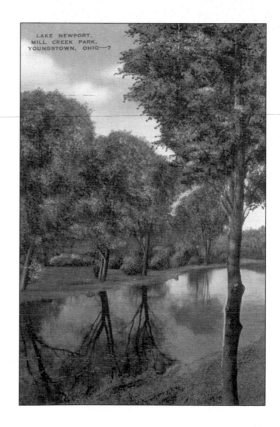

LAKE NEWPORT, MILL CREEK PARK. Lake Newport was the largest of the park's lakes and included seven islands. In the late 20th century, Lake Newport was dredged and is no longer the boating haven it was in the past.

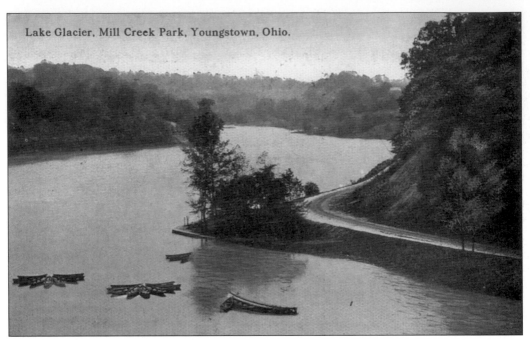

Lake Glacier, Mill Creek Park, Youngstown, Ohio.

LAKE GLACIER, MILL CREEK PARK. Between 1904 and 1906, a new dam was built along the Mill Creek, which created Lake Glacier. It is the second largest of the park's lakes.

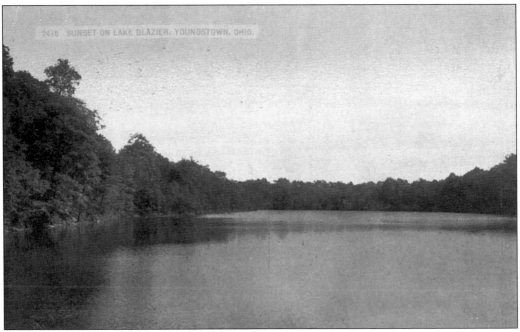

2416 SUNSET ON LAKE GLAZIER, YOUNGSTOWN, OHIO.

LAKE GLACIER. The area near Lake Glacier saw a significant amount of industrial activity prior to its creation. The old stone quarry, a slaughterhouse, and a soap factory were all located on land that became a part of Mill Creek Park.

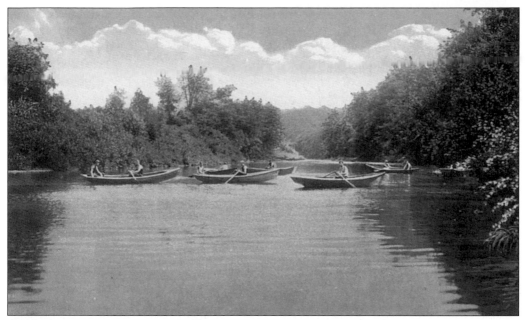

BOATING ON LAKE GLACIER. One of the more intriguing local industries located near Lake Glacier was ice harvesting. James A. Campbell (later president of the Youngstown Sheet and Tube Company), John Fitch and Alfred Smith formed the Youngstown Ice Company in 1883. Even after the establishment of Mill Creek Park, ice harvesting was still permitted within the park boundaries.

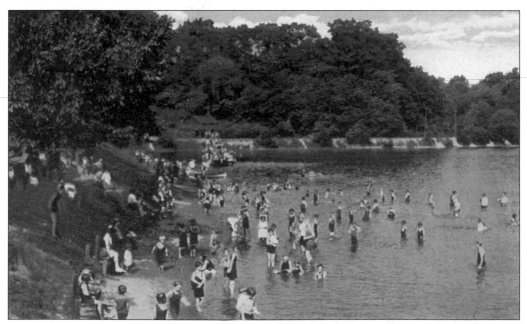

BATHING BEACH, LAKE GLACIER, MILL CREEK PARK. Many contemporary visitors to Mill Creek Park do not know that swimming was once allowed in the park's lakes. Beginning in 1899, Lake Cohasset was open to swimmers; Lake Glacier followed suit when it opened in 1906. Note the misspelling of Lake Glacier on the postcard.

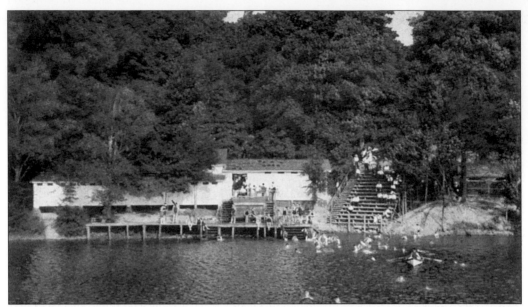

BATHING PAVILION, LAKE GLACIER. There were two bathing pavilions at Lake Glacier that were located on either side of the lake. Swimmers could rent bathing suits for 20 cents an hour. By the 1930s, swimming was discontinued in Mill Creek Park, partly because of competition from Idora Park's swimming pool.

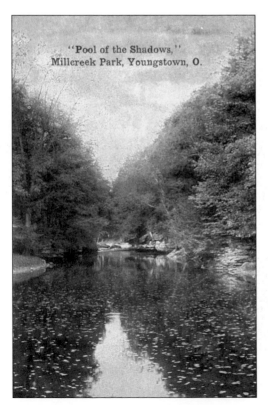

"POOL OF THE SHADOWS," MILL CREEK PARK. Located near Lanterman's falls, for many years the "Pool of Shadows" was believed to be a "bottomless pit." Although the pool's depth was finally determined in the 1930s, the site retains its mysterious-sounding name.

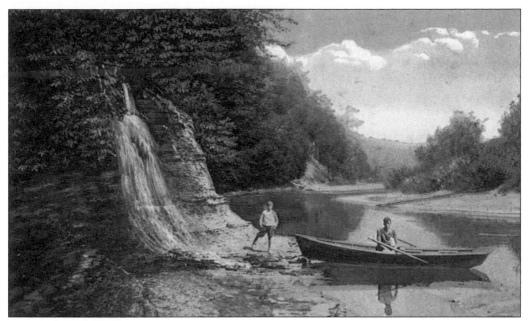

ABOVE DAM, MILL CREEK PARK. Boating was a popular activity on all of the lakes in Mill Creek Park. In 1900, a boat could be rented for 25 cents an hour, a price that most working class people could not afford.

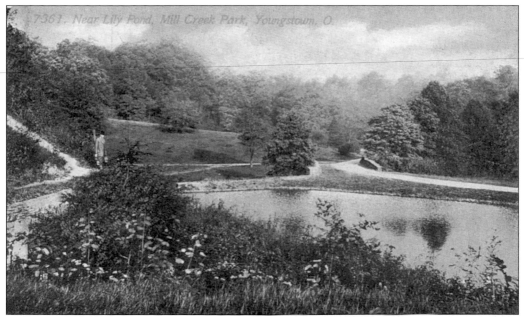

NEAR LILY POND, MILL CREEK PARK. In late summer, 1908, Mill Creek Park announced that five hundred bulbs had been planted in the new lily pond. The pond covered five acres of swamp. A stone bridge was also erected over the pond at the same time.

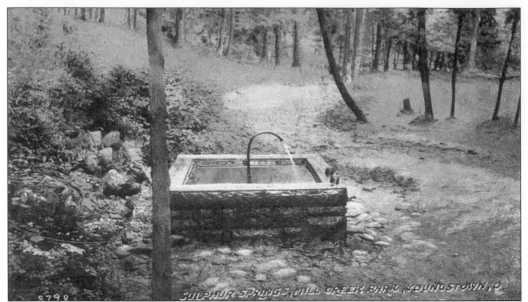

SULPHUR SPRINGS, MILL CREEK PARK. The sulphur springs actually predates the establishment of Mill Creek Park. The spring was created in the process of drilling for coal in 1884. Local physicians recommended the springs for its supposed curative powers. When the park opened, the springs continued to draw visitors. The Park and Falls Street Railway Company paid for improvements to the area around the springs in the hopes that increased visitation to the site meant more business for their trolleys.

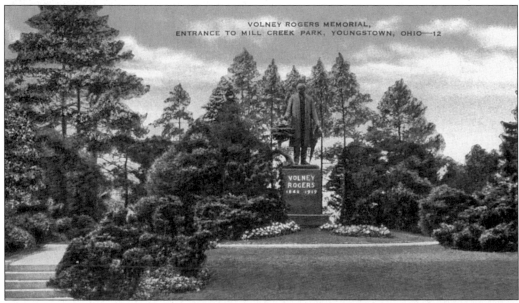

VOLNEY ROGERS MEMORIAL, ENTRANCE TO MILL CREEK PARK. This memorial to Volney Rogers that graces one of the Glenwood Avenue entrances to Mill Creek Park is a monument to his foresight and tenacity in establishing and maintaining one of the loveliest parks found in any urban area. The memorial was dedicated in 1920, following Rogers' death the year before.

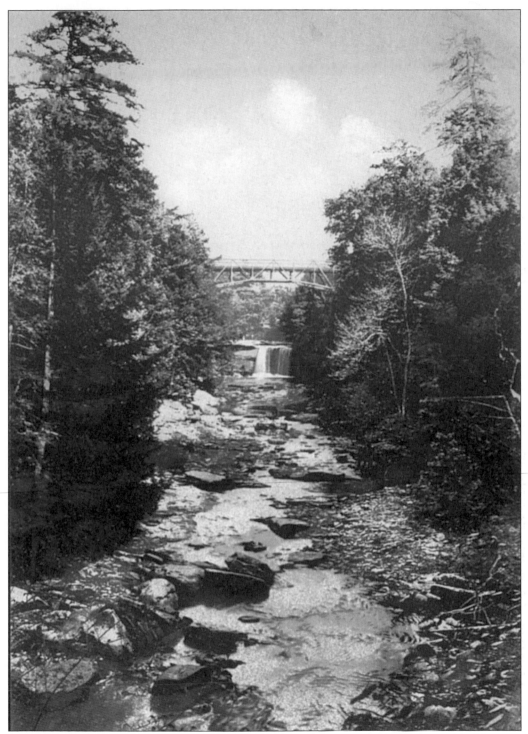

LOOKING UP MILL CREEK TOWARD THE FALLS AT THE OLD MILL. Mill Creek's falls were discovered in 1797 by two early Youngstown settlers, Isaac Powers and Phineas Hill. Over time, the falls provided power to several mills at this site.

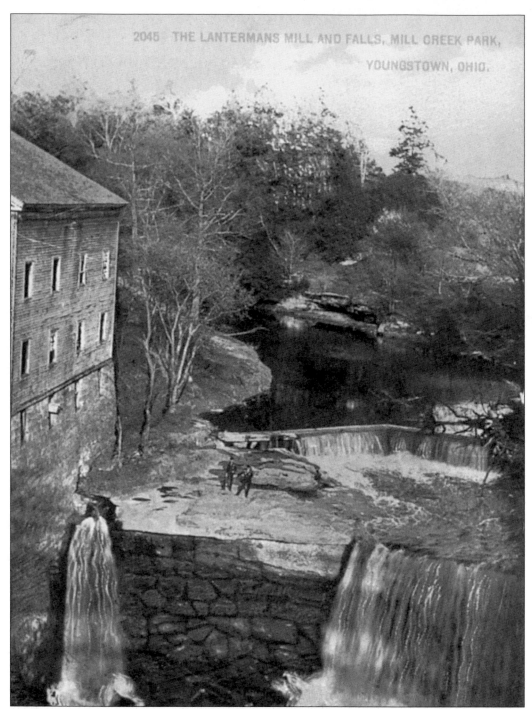

THE LANTERMAN'S MILL AND FALLS, MILL CREEK PARK. Lanterman's Mill is actually the third mill built at this site. In 1798, Isaac Powers built a mill on land he leased from Phineas Hill. Homer Baldwin, who eventually built a gristmill near downtown, constructed the second gristmill on this site in about 1823. After a flood washed away Baldwin's Mill in 1843, German Lanterman built the structure seen here.

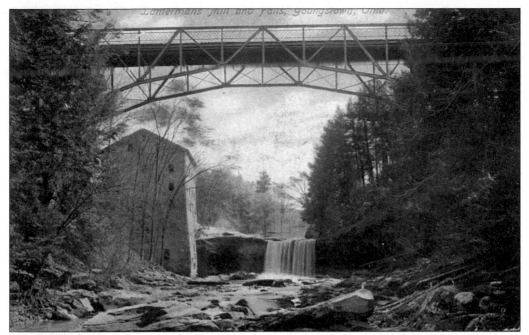

LANTERMAN'S MILL AND FALLS. German Lanterman's operation lasted until 1888. Originally, the overshot mill harnessed the available water power until it was later replaced by turbines shortly before its closing.

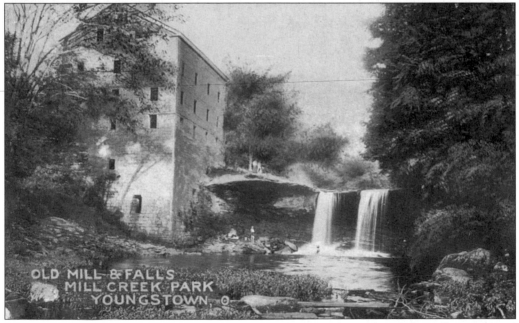

OLD MILL AND FALLS, MILL CREEK PARK. Mill Creek Park purchased the mill in 1892 and converted it into a dance hall and a storage space for boats. The park rehabilitated the first floor into a nature museum in 1933, which became an historical museum in 1972. Today, it is again a working mill open to visitors.

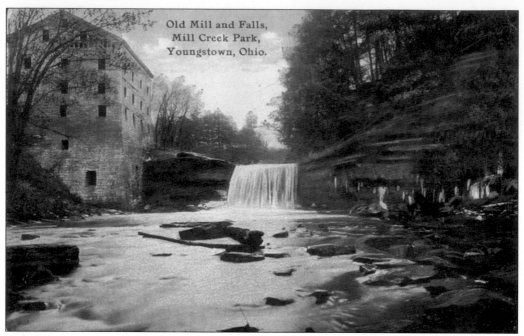

OLD MILL AND FALLS, MILL CREEK PARK. The mill and falls were such great attractions to the park, that the Park and Falls Street Railway Company considered it as a possible southern terminus for the trolley line, until it built Idora Park in 1899.

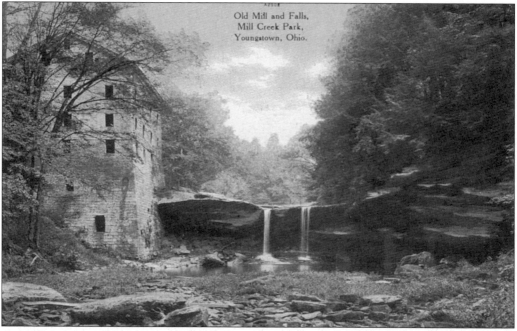

OLD MILL AND FALLS, MILL CREEK PARK. The picturesque quality of the mill and falls made it the subject of many postcards as seen here and in the following images (as well as on page 4). Note the different angles and varying amount of water going over the falls in the following two images and the image on page four.

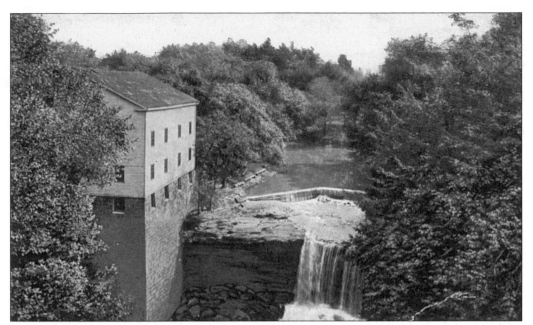

THE OLD MILL AND FALLS, MILL CREEK PARK.

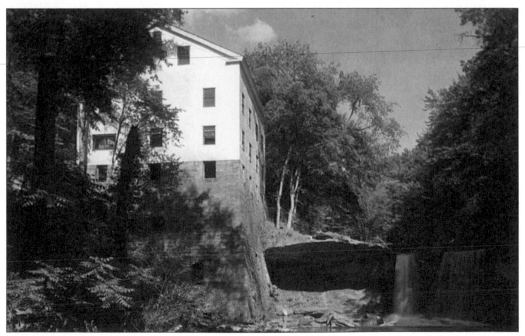

THE OLD MILL AND FALLS, MILL CREEK PARK.

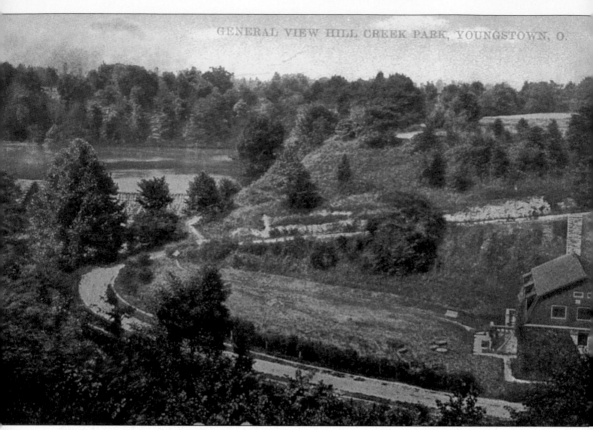

GENERAL VIEW HILL CREEK PARK, YOUNGSTOWN, O.

GENERAL VIEW, MILL CREEK PARK. This view gives a sense of the vistas that entranced park goers. The gently rolling hills, bountiful trees and quaint buildings were a far cry from the crowded, noisy industrial community of Youngstown.

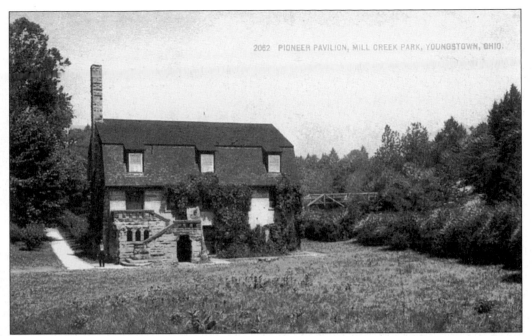

PIONEER PAVILION, MILL CREEK PARK. The Mahoning Valley's first iron masters, brothers James and Daniel Heaton, erected this building in 1821 as a woolen mill. The mill stood next to a stone stack iron furnace that the Heatons built in about 1832. Originally, the furnace used charcoal for fuel; in 1846 it was converted to a coal furnace. The furnace went out of blast by 1850. In 2003, Dr. John White of Youngstown State University began a dig at the site of the furnace.

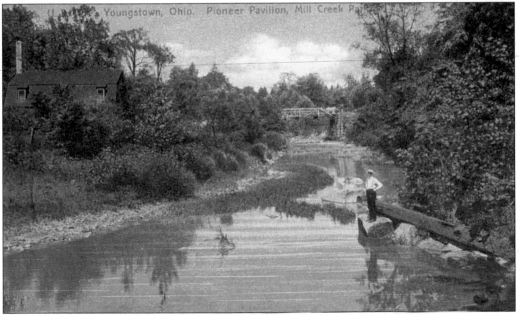

Youngstown, Ohio. Pioneer Pavilion, Mill Creek Park

PIONEER PAVILION, MILL CREEK PARK. In about 1830, the woolen mill closed. The building then served as storage for the nearby iron furnace, and later as a cow barn until the establishment of Mill Creek Park in 1891.

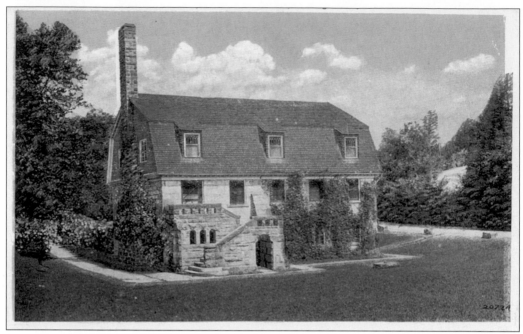

PIONEER PAVILION, MILL CREEK PARK. In 1893, Mill Creek Park's commissioners renovated the building for use as a pavilion. The walls of the building are original; the dormers and the second story were 1890s additions. The pavilion has a dining room and kitchen on the first floor and dance hall/meeting room on the second floor, which features an exposed wood trussed roof and an elaborate fireplace.

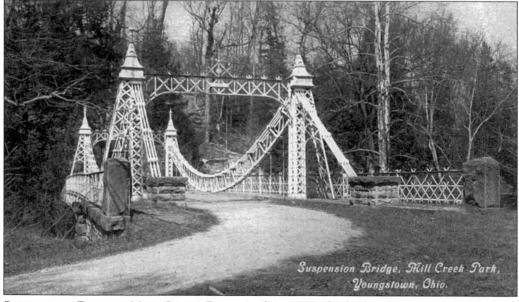

SUSPENSION BRIDGE, MILL CREEK PARK. Built in 1895, this bridge that spans the Mill Creek gorge is the oldest one still in use in Mill Creek Park. The steel suspension bridge has been known by a variety of names, including the White Bridge, the Old Steel Bridge, the Cinderella Bridge and the Fairy Tale Bridge.

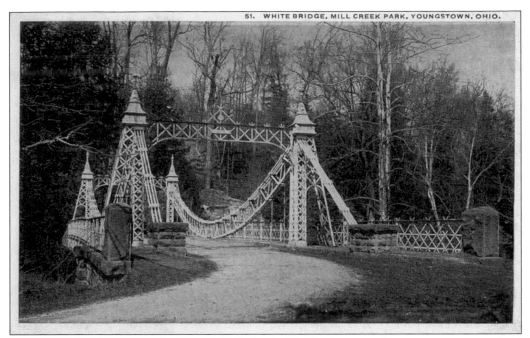

WHITE BRIDGE, MILL CREEK PARK. This image of the Suspension Bridge bears one of the many alternative names for the span. The fanciful structure is 86 feet long and 32 feet wide. It crosses Mill Creek between the Hiawatha Flats and the west side of the gorge.

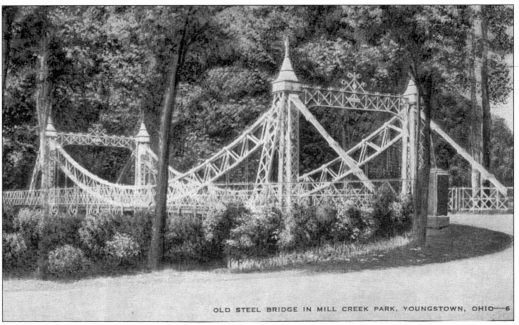

OLD STEEL BRIDGE IN MILL CREEK PARK, YOUNGSTOWN, OHIO—6

OLD STEEL BRIDGE IN MILL CREEK PARK. There is some disagreement as to what company actually built the Suspension Bridge. Some sources indicate it was the Youngstown Bridge Company, while others suggest it was Andrew Carnegie's American Bridge Company.

109

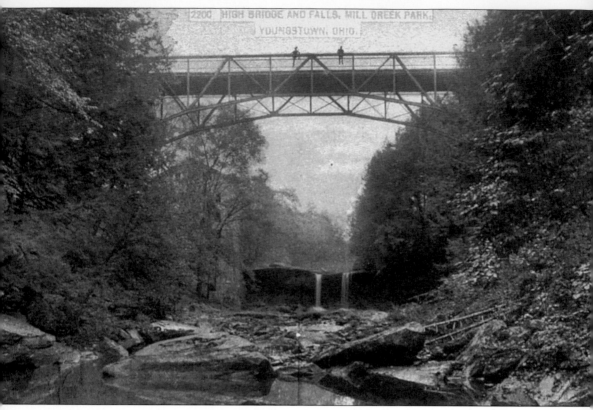

HIGH BRIDGE AND FALLS, MILL CREEK PARK. The iron bridge seen here was erected in 1883, some eight years prior to the establishment of Mill Creek Park, replacing an earlier wooden bridge. This 73-foot tall structure spanned the gorge just north of Lanterman's Falls, which is visible here.

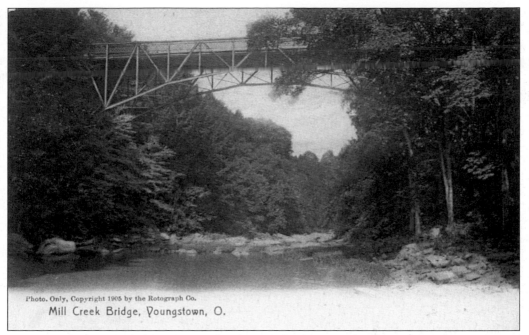

Mill Creek Bridge, Youngstown, O.

MILL CREEK BRIDGE. This appears to be the same bridge as High Bridge, although Lanterman's Falls looks as if it was airbrushed out of the image. In 1920, the iron bridge was replaced with a concrete and steel span to carry automobile traffic.

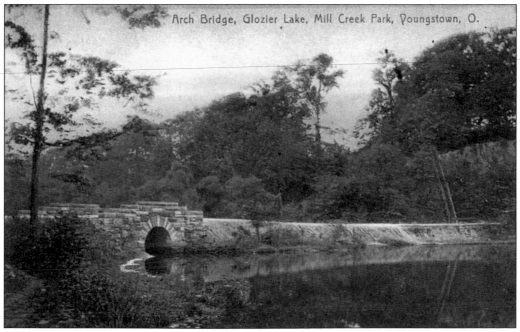

Arch Bridge, Glozier Lake, Mill Creek Park, Youngstown, O.

ARCH BRIDGE, GLACIER LAKE, MILL CREEK PARK. The stone bridge that crosses Lake Glacier makes use of the abundant stone found in the park.

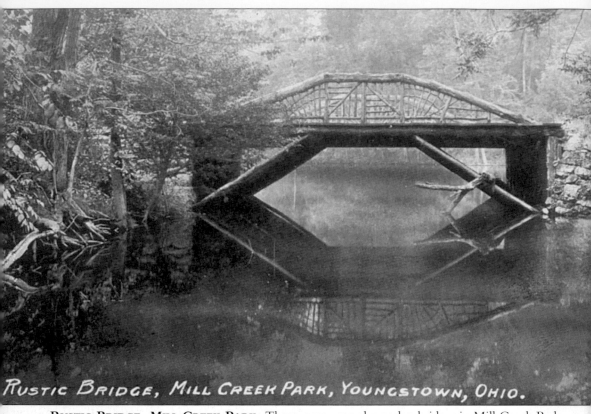

RUSTIC BRIDGE, MILL CREEK PARK, YOUNGSTOWN, OHIO.

RUSTIC BRIDGE, MILL CREEK PARK. There were several wooden bridges in Mill Creek Park. This was an attempt to capitalize on the bucolic nature of the park's natural beauty.

SLIPPERY ROCK, MILL CREEK PARK. The name "Slippery Rock" applies to a large area on either side of Mill Creek at the northern end of the park. There are a number of stories as to exactly which large boulder gave its name to the area. The modern park has a number of sites with "Slippery Rock" in the name including a recreation area, pavilion, and meadow.

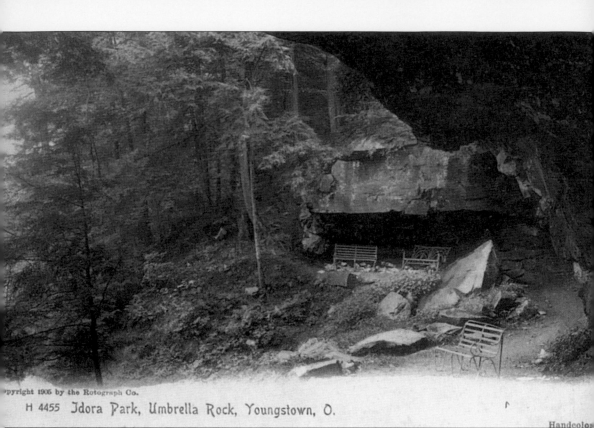

H 4455 Idora Park, Umbrella Rock, Youngstown, O.

IDORA PARK, UMBRELLA ROCK. The proximity of the amusement park to Mill Creek Park resulted in the confusion about the location of the Umbrella Rocks. This formation is located very near the site of Idora Park.

Seven
IDORA PARK

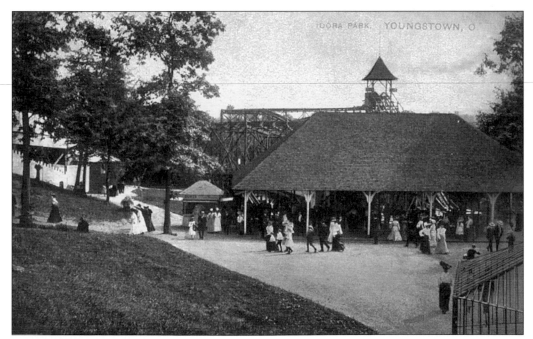

IDORA PARK. Opened on Memorial Day, 1899, Idora Park originated as a trolley park built by the Youngstown Park and Falls Street Railway Company. The figure eight roller coaster shown here was an early addition to Idora, debuting in the 1902 season.

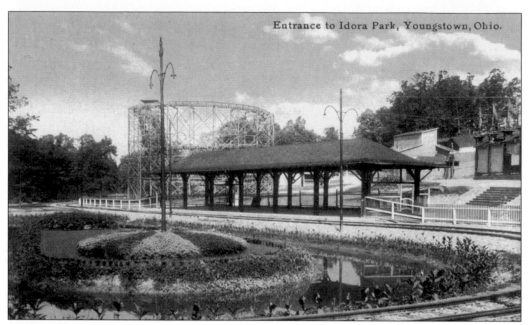

ENTRANCE TO IDORA PARK. When Park and Falls opened its new "pleasure park," it was originally called Terminal Park. The trolley company ran a contest to select the favorite teacher in the Youngstown Public Schools, who was given the honor of naming the attraction. The winner, Emily Gettins, selected the name "Idora." There is some question as to where the name "Idora" originated. The most commonly accepted version is a play on "I adore a park."

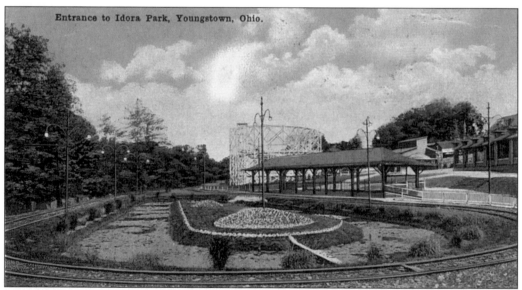

ENTRANCE TO IDORA PARK. Park management built this shelter and trolley turnaround for the 1910 season, necessitated by an injunction filed by local property owners alleging that one of the park's fences hindered entrance to and egress from their street. The injunction further alleged that the park's fences also served as an attempt to eliminate "the stores and amusement places which are outside of the park and from which the company gets no percentage of the profits of patrons of Idora Park."

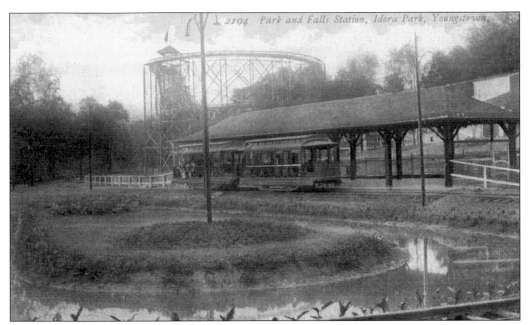

PARK AND FALLS STATION, IDORA PARK. The new trolley park proved to be a gold mine for Park and Falls. Within a short time, the traction company became the most profitable in Youngstown. The shelter where park goers were dropped off and picked up is seen here, along with one of the open air summer trolley cars.

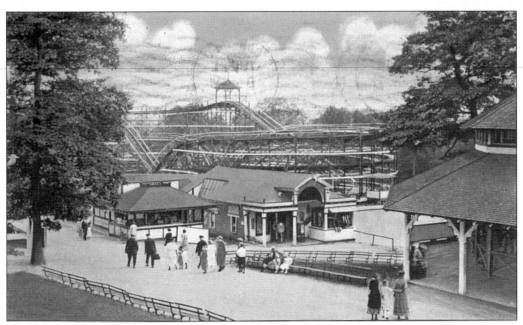

VIEW OF IDORA PARK. This *c.* 1920 view shows two of Idora's main attractions: the "Firefly" roller coaster and the building housing the carousel. In 1922, an impressive Philadelphia Toboggan Company carousel replaced an earlier Dentzel machine.

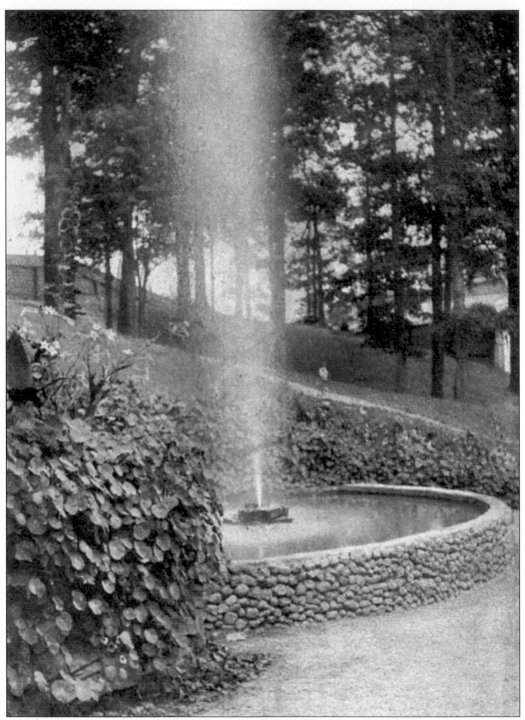

FOUNTAIN AT IDORA PARK. The proximity to Mill Creek Park enabled Idora to take advantage of the beauty of its natural surroundings. The *Vindicator* often described the wooded setting, noting in 1900 that it was "one of the finest in the state," "one of the most beautiful sylvan spots in the country," and the "great breathing spot of the city."

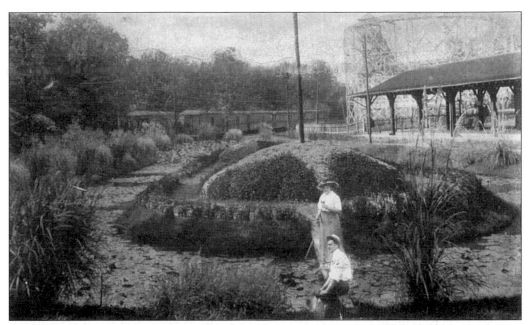

THE LAGOON, IDORA PARK. The juxtaposition of Idora's mechanical attractions such as the roller coaster in the background with flora and fauna is evident in this postcard.

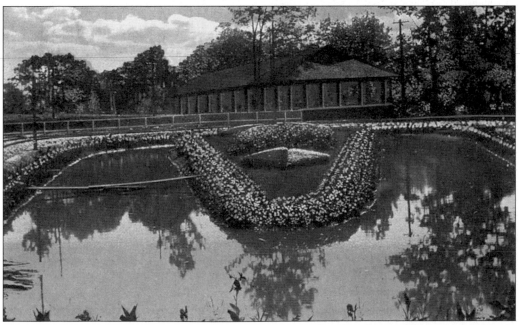

LAGOON AT IDORA PARK. Unlike many amusement parks, Idora did not have a natural body of water on its grounds. This lagoon was the product of human hands, not nature.

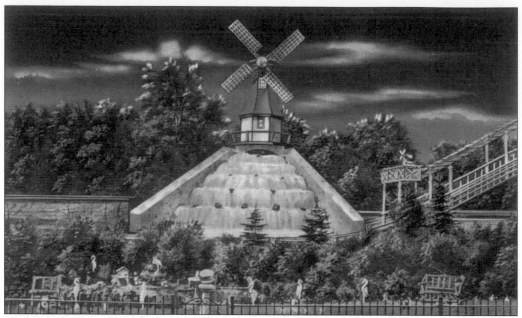

THE RAPIDS OF OLD MILL, IDORA PARK AT NIGHT. Debuting in the 1930 season, the "Rapids" was a combination of a water ride and dark ride. It replaced an earlier, similar ride that was first known as the "Panama Canal" and later was re-themed as the "Wizard of Oz."

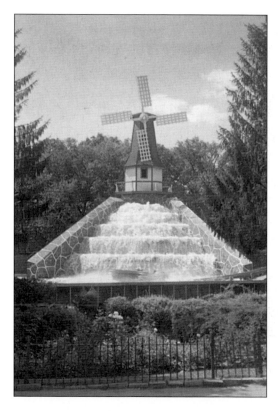

THE RAPIDS, IDORA PARK. The "Rapids" featured a long boat ride through a tunnel that had scenes to amuse and frighten riders. At the end of the ride, the boats went up a hill and then splashed down in the pool in front of the mill.

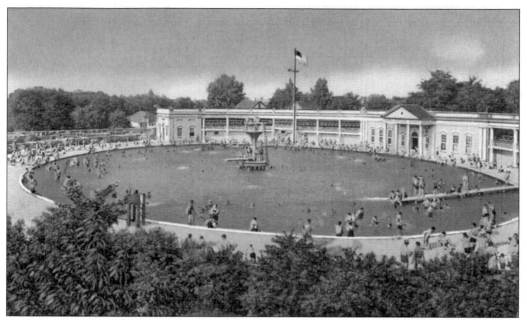

SWIMMING POOL IN BEAUTIFUL IDORA PARK. Since Idora did not have a natural body of water as did other parks like Euclid Beach Park in Cleveland, management constructed a swimming pool. Built in 1924, the swimming pool quickly became one of Idora's most popular attractions.

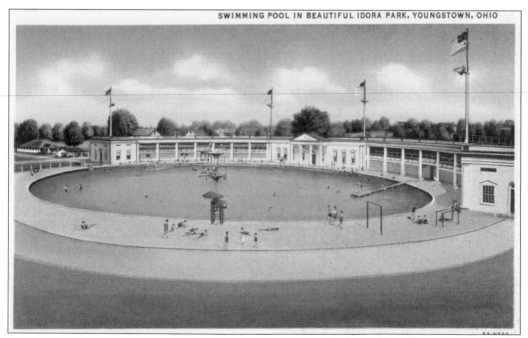

SWIMMING POOL IN BEAUTIFUL IDORA PARK, YOUNGSTOWN, OHIO

SWIMMING POOL IN BEAUTIFUL IDORA PARK. The oval pool was 210 feet by 160 feet, surrounded by 20 feet of white sand. At the deepest point, the pool was 10 feet, 6 inches deep. The Heller-Murray Construction Company of Youngstown built the pool and the semi-circular Georgian Revival bathhouse behind it.

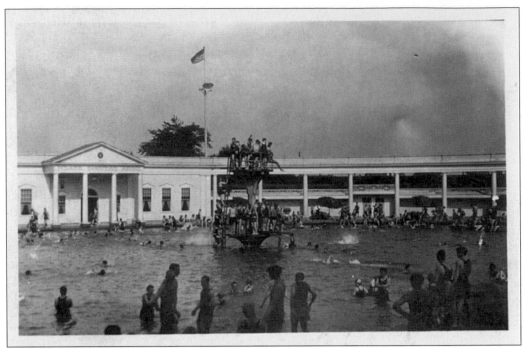

SWIMMING POOL, IDORA PARK. Idora's management exploited the search for improved health with its pool, boasting that the "water was pure enough to drink." Idora circulated its 1.2 million gallons of water through a filtration system every twenty-four hours.

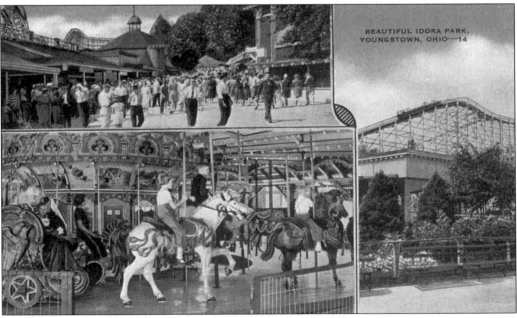

BEAUTIFUL IDORA PARK. This postcard probably dates from about 1950 and showcases three of Idora's attractions (clockwise from upper left): the midway, the "Wildcat" roller coaster and the 1922 Philadelphia Toboggan Company carousel. The carousel has the distinction of being the first one listed on the National Register of Historic Places.

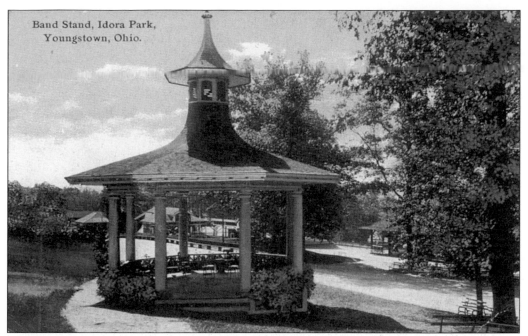

BAND STAND, IDORA PARK. Free band concerts were an important attraction in the early years of Idora Park. This type of "middle class" entertainment existed alongside less uplifting presentations at the park, including Mlle. D'Acos (the "Human Electric Light") and the diving horses, "Cupid" and "Powder Face."

VIEW IN IDORA PARK. A number of Idora's attractions were free, including admission to the park itself. This meant that working class people could enjoy a day at Idora, right alongside middle and upper class citizens. The only cost was the nickel trolley fare out to the park from downtown.

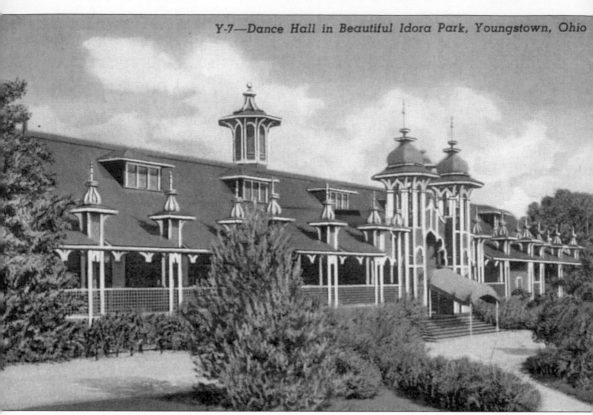

DANCE HALL IN BEAUTIFUL IDORA PARK. In 1910, Idora Park opened its new dance hall (later called the ballroom), which was designed by Youngstown architect Angus Wade. This fanciful concoction of Moorish ogee arches and Russian onion domes provided a stark contrast with contemporary public buildings like the Mahoning County Courthouse and Public Library. The dance hall's architecture signaled to visitors that this was a place where they could escape from the workaday world if only for a lazy afternoon.

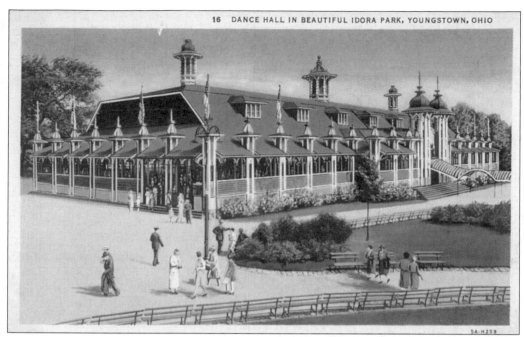

DANCE HALL IN BEAUTIFUL IDORA PARK. Idora's dance hall boasted one of the largest dance floors in the region. Over the years, the park showcased the best in musical entertainment, including the Jimmy and Tommy Dorsey Orchestras, Louis Armstrong, and Buddy Rich.

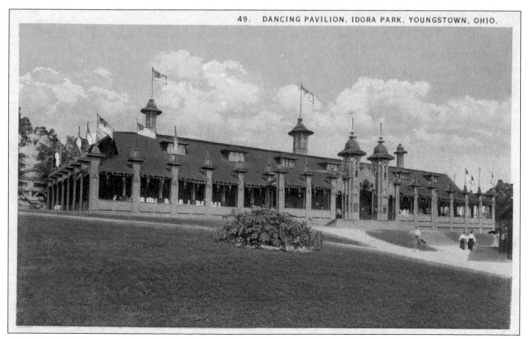

DANCING PAVILION, IDORA PARK. The dance hall became a center of controversy in 1915 when park management banned modern dances. The ban was short lived, when manager Royal E. Platt announced that all new dances except for the fox trot were permitted on Monday evenings. Within a few years, modern dances were permitted five nights a week.

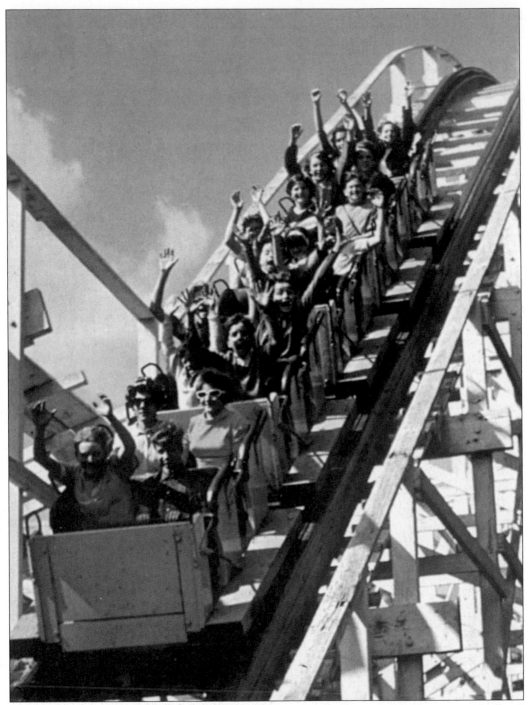

THE WILDCAT, IDORA PARK. One of the truly great American roller coasters, the "Wildcat" debuted in the 1930 season. Created by leading coaster designer Herbert Schmeck of the Philadelphia Toboggan Company, the descent of the ride's first (or lift) hill was remodeled in 1940. Until the park's closing in 1984, the "Wildcat's" steep dips and hairpin turns provided a bone jarring, truly exciting ride.

126

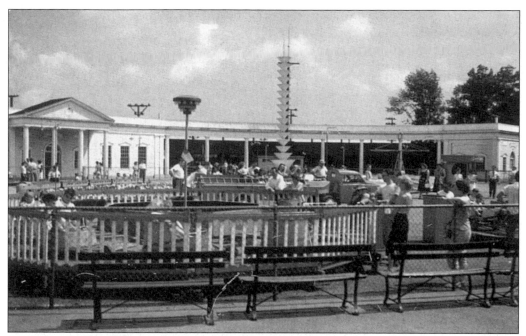

KIDDIELAND, IDORA PARK. In 1949, Idora closed its swimming pool. While management gave no clear reason for doing so, several theories have been suggested, including falling revenues due to competition from city pools and to diffuse the pool's role as a possible lightning rod for increasing racial tensions. Two years later, Kiddieland debuted in the space once occupied by the pool.

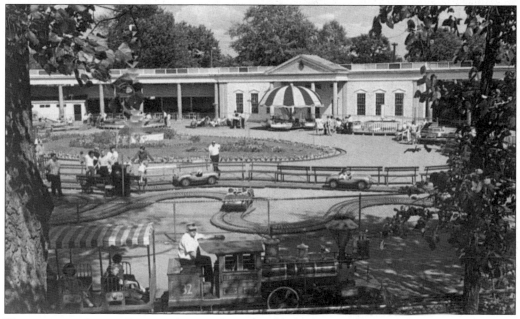

KIDDIELAND, IDORA PARK. The opening of Kiddieland meant the park had an attraction for the burgeoning post–World War II baby boomers. While most of Idora's rides were clearly for older children and adults, Kiddieland was strictly for the toddler and younger child. Kiddieland even featured a child-sized roller coaster.

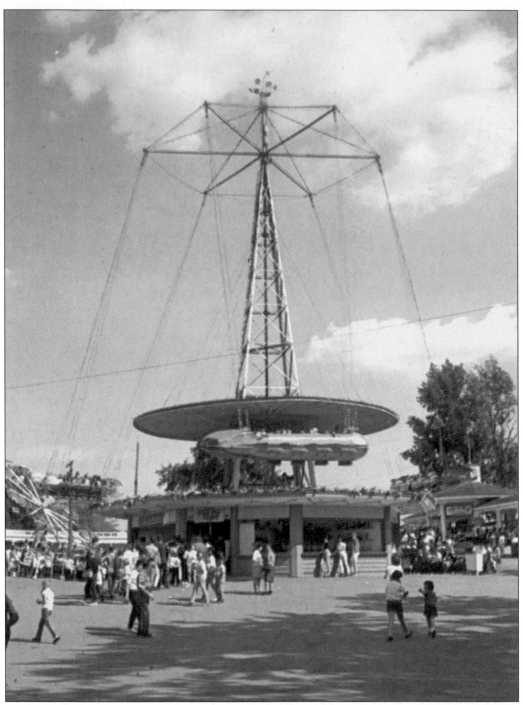

ROCKET SHIPS, IDORA PARK. The "Rocket Ships" were the third incarnation of Idora's original circle swing, which featured wicker gondolas. Propeller planes followed the gondolas and, in 1948, Idora entered the space age with the silvery rocket ships seen here. The "Rocket Ships" were a mainstay of the park until a disastrous fire that destroyed a major portion of the "Wildcat" spelled an end to Youngstown's "Million Dollar Playground" in 1984.